watercolours
IN A WEEKEND

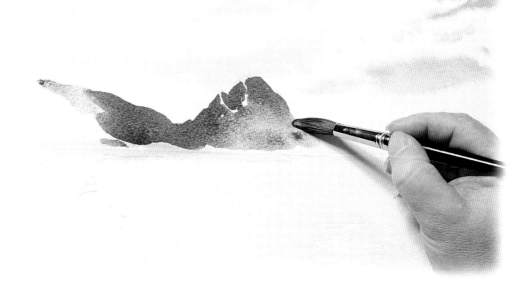

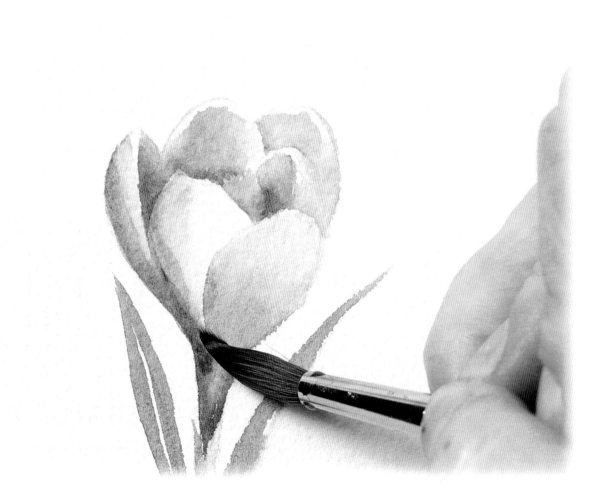

HAZEL HARRISON
watercolours
IN A WEEKEND

pick up a brush and paint your first picture this weekend

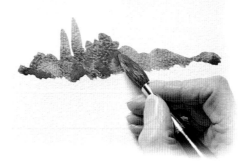

David & Charles

A DAVID & CHARLES BOOK

First published in the UK in 2000
Reprinted 2002
First published as paperback 2002

A catalogue record for this book is available from the British Library.

ISBN 0 7153 1107 7 (hardback)
ISBN 0 7153 1392 4 (paperback)

Printed in Hong Kong by Dai Nippon
for David & Charles
Brunel House Newton Abbot Devon

Commissioning Editor Anna Watson
Desk Editor Freya Dangerfield
Designer Maria Bowers

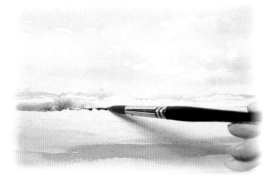

contents

Introduction 6
Painting Materials 8

THE PAINTING COURSES 18

Course 1 LAND AND SKY 20
Saturday exercises 22
Sunday painting: Summer Landscape 30

Course 2 LAND AND WATER 40
Saturday exercises 42
Sunday painting: Sunset over Jackson Lake 48

Course 3 TREES 56
Saturday exercises 58
Sunday painting: Willow Trees in Summer 66

Course 4 BUILDINGS 74
Saturday exercises 76
Sunday painting: Tunisian Scene 82

Course 5 FLOWERS 90
Saturday exercises 92
Sunday painting: Winter Bouquet 100

Course 6 STILL LIFE 108
Saturday exercises 110
Sunday painting: Fruit with a Blue and Orange Bowl 118

Credits 126
Index 127

INTRODUCTION

An important factor in starting to paint is continuity. It's a bit like learning to drive – you will gain knowledge and confidence faster if you take seven lessons in one week than if you spread them over two months. This book, aimed primarily at those who have never yet picked up a brush, works on the same principle, providing a 'crash' painting course via a series of weekend courses, each of which is designed to be done on two consecutive days. You will spend Saturday on structured painting exercises, trying out various techniques, and on Sunday you will put these into practice to complete an entire painting based on the work of one of our chosen demonstration artists. Of course, the courses need not be restricted to weekends: those with more time on their hands can choose any two days, but you will get the most out of the course if you stick to the basic structure – exercises on the first day and the painting on the second.

The six demonstration paintings cover a wide field of subject matter from landscapes to flowers, buildings and still life, and each of the artists has their own distinctive style and method of working. The beauty of the book is that you can pick and choose – you need not work through it in order. So flip through the pages first, and if one painting has a special appeal, then start with this and move on to another in your next session. But do try out as many as you can and, for additional inspiration, also study the selections of finished paintings at the start of each of the courses. When you are new to painting it is vital to keep your mind open to ideas, experimenting with different subjects and different methods of building up a painting. Only in this way will you eventually discover your own artistic interests and your individual language of self-expression.

Learning from experience

Don't be discouraged if your paintings don't turn out exactly the same as those of the demonstration artists. Even in expert hands, watercolour can be an unpredictable medium, indeed this is one of its many charms. You may sometimes find that you have failed to achieve a specific effect, but have quite accidentally achieved another, which might be used to advantage in a later painting. For example, splodges and runs need not always be seen as mistakes; many artists exploit these to create interest in a painting. So always keep an eye out for happy accidents and regard them as part of the learning curve. Never throw away your first attempts, even if you see them as failures. Instead, keep them to compare with later works done when you have begun to get the feel of the medium – you will almost certainly feel a glow of satisfaction at how much progress you have made in a short time.

The watercolour medium

This book does not aim to provide a set of rules for painting with watercolour; the emphasis is on learning by doing. However, it is important to bear in mind the main characteristic of the medium, which is its transparency, because this affects both the way you work and also the appearance of the finished painting. Because the colours are transparent, watercolours are worked in a series of layers, starting with the lightest colours and gradually working up to the darks. But care must be taken not to lay too many layers on top of one another, or the colours may become muddy and dull, and you will find you have sacrificed the quality of translucency that gives a good watercolour its special appeal. So follow the example of our artists and work in planned stages, always beginning with a drawing so that you know where to place the first colours, and if you make a mistake, don't try to put it right by painting over it; simply wash the wrong colour out with a sponge and try again.

The structure of the book

The painting courses, starting on page 20, form the major part of the book, and there is more information on how they work on page 18. Before this there is a short section giving you advice on the paints and other equipment you will need for the courses.

PAINTING MATERIALS

This short section gives advice on the paints and other equipment you will need for the weekend painting courses. If you have not painted before, you will find the advice on colours especially useful as it is only too easy to go wrong and buy colours with tempting names which later prove unnecessary. A palette of 12 colours is recommended on page 9, and these will be used for the majority of the painting projects.

The chapter also gives advice on brushes, paper, and additional equipment such as palettes and waterpots, together with hints on how to organize your workspace, whether it is in the corner of a kitchen table or a room dedicated solely to painting. So read these pages carefully before you go shopping for paints and equipment, and never buy more than you need – you can add extra colours, special brushes and so on later as you become more sure of your needs.

the workspace

Space does not matter quite as much to the watercolour painter as it does to those working in oils or pastels. One of the other advantages of the medium is that your paints and equipment can be quickly tidied away, and any occasional paint splashes can be wiped down, leaving no stains.

working position

The majority of watercolour painters work sitting down, with a drawing board either propped up on a book or brick, or held on a table easel at a slight angle. But once you have begun to paint you may find that you need to alter both your own position and that of your board. For example, if you are beginning a painting with wet washes, and your board is held on a table easel, the paint will run down the paper. For this reason, some artists prefer to work the wet-into-wet stages standing up, with the board laid flat on the table. This is a good position for large-scale work, as it allows you more freedom of hand movement and encourages flowing brushstrokes.

Both artists lay the first wet washes standing up, working on a table easel held at a shallow angle. The easel can be adjusted as the work progresses; for example, the more detailed painting might be done sitting down with the board held in a more upright position.

points to watch

There are one or two factors that will affect the painting process, the major one being light. It is very distracting if strong sunlight and shadow is thrown onto your work, so, if possible, avoid using a table directly under a sunny window. North light is the best, as it changes very little through the day, but you may not have the choice. Ideally the light should come over your left shoulder – or right, if you are left-handed – as this avoids casting a shadow from your working arm.

artificial light

In the winter months, when daylight hours are limited, you may want to work with artificial lights. It is best to avoid ordinary electric-light bulbs (tungsten), as these give a strong yellow cast to colours. Some forms of kitchen strip-lighting may be adequate for painting, or you can buy an adjustable desk lamp and use it with one of the special daylight-simulation bulbs that are sold in most art shops.

LAMP
Adjustable table lamps are inexpensive and readily available in most department stores. But check the maximum wattage; some can only be used with a 40-watt bulb, which may not provide enough light. 60-watt is sufficient for most purposes.

DAYLIGHT BULBS
These can be bought in most good art shops, with wattages ranging from 40 to 100 watts. They are extremely useful, as they do not distort colours, unlike ordinary tungsten bulbs, which give a distinctive yellow cast.

paints

If you have never painted before, buying your first set of watercolours without guidance can be a hit-and-miss affair. The names of the colours printed on the tubes or pans will not mean much until you have started to use the paints, and art shops carry a confusingly wide range, tempting you to buy more colours than you need. A sound rule is to start with the minimum, buying one or two extra colours later if you find you need them. The palette of 12 colours listed on the opposite page is adequate for most subjects and is the one you will be using throughout the book.

Pans, half-pans and tubes of paint can all be bought individually. Tubes are made in two sizes, the standard size being 5ml. The larger tubes (15ml) are mainly used by designers and illustrators.

tubes and pans

Before you purchase your basic palette you will have to make another important choice – whether to buy the colours in tube or pan form. Many artists use pans (or half pans), and they are handy for outdoor work, but they are now rather less popular than tubes. Pans and half pans are designed to fit into special slots in a metal paintbox. Most manufacturers offer paintboxes complete with the pans in place, but these are expensive and limit your choice of colours. Empty paintboxes that you fill with your own choice of colours are available but tend to be difficult to obtain.

Tubes, on the other hand, have a double advantage. First, they involve little extra expense, because you can squeeze out the

paint as you need it onto an inexpensive plastic or ceramic palette (see page 16) – or even onto an old dinner plate to start with. Second, you can mix up large quantities of colour very quickly from moist dollops of paint straight from the tube, whereas you sometimes have to scrub at a pan with your brush for some time in order to release enough colour for a broad wash.

the basic palette

Most people are familiar with the theory that all colours can be mixed from the three primaries – red, yellow and blue. There is some truth in this, but you will not achieve satisfactory mixtures with just three colours. This is because there are different versions of each of the primaries, described by artists as 'warm' and 'cool' (see right). These behave very differently in mixtures, so you will need two of each primary colour. Browns and greens, plus one grey, are also included in the suggested palette, not only because these are laborious to mix from other colours, but also because they are useful in their own right.

artists' and students' colours

Most major manufacturers offer two different ranges of paints, one labelled 'artists' watercolour', and the other usually bearing a brand name of the manufacturer's devising. It is advisable to buy the more expensive artists' paints, as the colours are stronger and purer; cheaper paints are made with a lower proportion of pigment and the results may be disappointing.

THE BASIC PALETTE

 Indian yellow A strong, warm yellow, tending towards orange.

Lemon yellow An acid, cool yellow with a hint of green.

 Yellow ochre A muted, slightly brown yellow, useful on its own or in mixtures for browns and greens.

 Cadmium red A pure, bright, warm red. Mix with cadmium yellow to make orange.

 Alizarin crimson A cooler red, tending towards blue. Mix with ultramarine to make purple.

 Ultramarine Excellent all-purpose blue, used on its own or in mixtures.

 Phthalo blue A cooler, slightly green blue. Phthalocyanine is the name of the pigment, but this blue is sometimes given a manufacturer's name, such as Winsor blue.

 Sap green A strong, bright yellowish green. Can be used on its own for strong colour accents, or modified with other colours.

 Viridian A dark, bluish green. Can look artificial if used on its own, but excellent in mixtures.

 Burnt umber A dark reddish brown, good both on its own and in mixtures, especially combined with ultramarine for greys.

 Raw umber A greener, natural brown, good both on its own and in mixtures.

 Payne's grey A blueish grey, ideal in mixtures for muted greens and neutral colours.

brushes

One of the great attractions of watercolour work is that you do not need a great deal of equipment. An oil painter may require upwards of 12 brushes, but the fortunate watercolourist can manage perfectly well with two or three, and many paintings are worked from start to finish with just one.

THE BRUSHES SHOWN HERE ARE:
A and B . . round brushes
C flat brush
D rigger brush
E mop brush
F Chinese brush

first choice

The main difficulty for the novice is buying 'blind'. Tools are chosen according to the job in hand, and before you have begun to paint you will not really know what the work involves. There are many different brushes, but until you begin to evolve your own way of working, restrict yourself to the two basic brush shapes, rounds and flats, and discover what they can do.

Flat brushes are especially suited to laying washes, but can also be used to make linear, sweeping strokes that might describe grass or foliage. You will not need more than one of these, so choose a middle size, say 12mm (½in) or 20mm (¾in). Round brushes are very versatile: you can use them instead of flats for washes, and they are capable of producing a varied range of brushmarks as well as fine detail. You should have two of these in different sizes – a No. 10, 11 or 12 (medium large) and a No. 2 or 3 for detail and smaller strokes.

adding to your toolkit

As you become more experienced you will probably want to experiment with additional brushes. Painters who like to work wet-into-wet often use a mop brush (sometimes called a wash brush). These brushes are softer than other watercolour brushes and are usually made of squirrel hair, so they are only suitable for broad, free effects.

Some artists find rigger brushes useful. These were originally designed for painting ships' rigging, hence their name, and they are excellent for fine detail such as small branches and twigs in landscapes. Chinese brushes are a favourite with today's watercolourists. These come to a fine point, and are ideal for calligraphic effects.

Paint can also be applied with a small sponge. It can be used for lifting-out methods (see pages 26–27), for correcting mistakes, laying washes and for stippling textures.

materials for brushes

During the nineteenth and early twentieth centuries all watercolour brushes were made of sable and were very expensive, as they are today. Sable brushes are still much prized, but many excellent and inexpensive alternatives have appeared on the market as manufacturers have responded to demand and developed ranges of synthetic brushes. You might consider buying a sable or two as a treat later on, but synthetics, or sable and synthetic mixtures, are fine to start with.

BELOW: Marks made with a round brush.

ABOVE: Marks made with a flat brush.

BRUSH CARE

Your brushes will last more or less forever if you look after them well. The commonest cause of injury to brushes is leaving them face down in water, which will bend or splay out the hairs. Get into the habit of washing your brushes between colours and standing them upright in a container. At the end of a painting session, wash them well in warm water and a touch of soap.

If you are taking brushes out with you on a sketching trip, invest in a brush wallet or a special brush-carrier, such as a cylindrical clear-plastic container to protect them.

WRONG. Never leave your brushes face down in water.

watercolour
paper

Watercolour paper is sold in various forms. Most art shops will offer you a choice of pads, ringbound sketchbooks or loose sheets that can be cut to the desired size. All of these will bear some form of labelling telling you the type of surface and the weight of the paper, and these are the two most important factors to consider.

The usual colour of watercolour paper is white, but tinted papers, frequently used by nineteenth-century artists, are again becoming popular. They are useful for paintings in which there are no white highlights, or for mixed-media work combining watercolour with gouache or pastel.

paper surfaces

Paper surfaces are divided into three categories: smooth, medium and rough. The medium one is officially known as 'NOT', a name that relates to its method of manufacture (it is actually short for 'Not Hot-pressed'). You need to remember this because you will not find the term 'medium' on manufacturers' labels.

NOT-surface paper, which has a slight texture but not an obtrusive one, is the most popular choice among both amateur and professional artists, and is the one recommended throughout the book, but you may want to experiment with other papers later on. The heavy texture of rough paper breaks up the brushmarks, which can give an exciting effect, but it makes it more difficult to paint fine detail. Smooth paper is very much an acquired taste: it has almost no texture, so the paint will often form pools or runs, which some artists like to exploit.

paper weights

The weight of watercolour paper describes its thickness, and is calculated according to the weight of a ream. This is expressed as grammes per square metre (gsm or g/m²) or in lbs, and sometimes both. Most blocks or pads of paper are 300gsm (140lb), but loose sheets offer a wider choice, weighing from 190gsm (90lb) to 425gsm (200lb) or even 640gsm (300lb).

The reason that paper weight matters is that thinner papers will buckle when you apply wet paint, so if you like to use a lot of water for wet-in-wet methods, you will need a heavy paper, or you can stretch a lighter one, as shown on the opposite page.

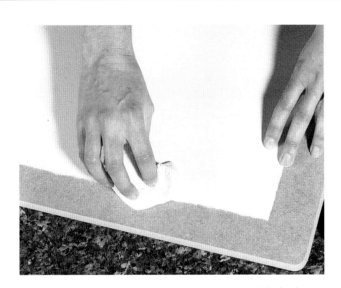

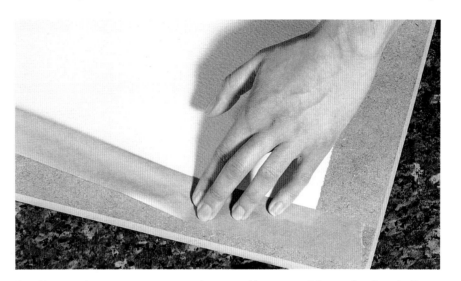

There are two ways of wetting the paper. You can soak it in the bath for a few minutes, then shake off the surplus water before positioning it on your board, or you can place the dry paper on the board and wet it well all over with a sponge or a damp cloth.

To stick paper down, you must use gumstrip, not masking tape or Sellotape. Cut the strip into the lengths required, wet it with a sponge or damp cloth and stick it down, overlapping the paper by at least 1.5cm (½in). Start with the two longer sides.

STRETCHING PAPER

The 300gsm (140lb) paper used for most blocks and pads is fairly robust, and is intended to be used unstretched for outdoor sketching. However, it can buckle if a great deal of water is applied, so stretching is a wise precaution if you are experimenting with wet-in-wet techniques. Any paper lighter than 300gsm (140lb) should always be stretched. The process is not difficult, and it can save you money, because you can buy a lighter paper rather than the much more expensive 425gsm (200lb), which does not need stretching.

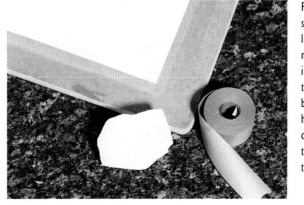

Finish with the two shorter sides, then leave the paper to dry naturally. You can place it near the radiator to speed up the drying, but do not use a hairdryer, as it can cause the gumstrip to tear away from the paper.

palettes
and other equipment

If you have bought your colours in tube form, you will need a palette that has areas for mixing colours as well as recessed wells to squeeze the colours into. Users of paintboxes may not need a palette because the opened-out lid provides space for mixing. However, it is wise to have an extra palette for mixing the large quantities of paint you may need for washes or wet-into-wet methods.

types of palette

There is a wide variety of palettes to choose from, some tailored for outdoor work and others suitable only for indoor painting. In the first category are light plastic palettes with thumbholes, designed to be used either standing or sitting. These are inexpensive, and are just as good as paintbox-lid palettes for outdoor work, provided you remember to take a plastic bag with you to put the dirty palette into.

For indoor painting you can choose from a selection of china or plastic palettes. A type popular with many artists is a circular china palette with a central well surrounded by smaller wells resembling the petals of a flower. Each of the wells is deep enough to hold a good deal of paint, making the palette ideal for large-scale work and wet-into-wet techniques. Some art shops offer small, individual china or plastic palettes that can be stacked on top of one another after a working session – a neat space-saving idea for those who work in the corner of a kitchen or living room.

Manufacturers produce a wide range of plastic and ceramic palettes, but individual art shops seldom offer more than two or three choices, so shop around if you can't get what you want immediately.

water containers

Your painting water can be held in more or less any waterproof container such as a jam jar or yoghurt pot, but there are two useful waterpots especially made for outdoor work. One is a plastic container that folds down flat before and after use, and the other is a pot with a non-spill lid – ideal for the clumsy, whether indoors or out. If possible, always carry extra water when working outdoors. You do not need to buy anything specially for this; soft-drink or mineral-water bottles are perfect.

other equipment

There are a few extra items that should form part of your painting kit. First, you will need pencils for making your preliminary drawing. These should be fairly soft; for example, a 3B or 4B is ideal for the kind of sketchy drawing you would use for a landscape, while for a more detailed fine-line drawing, perhaps for a flower painting, you may find a 2B or B more satisfactory. You will also require a plastic eraser for removing incorrect lines.

If you are working on paper you cut to size yourself, you will need a drawing board, and gummed brown paper if you intend to stretch the paper (see page 15). Purpose-made drawing boards can be expensive, but there are perfectly adequate substitutes available in DIY stores, such as plywood or MDF (medium-density fibreboard). Hardboard, too, makes an acceptable drawing board, but don't try to stretch the paper on it, as it will warp.

The last two items are not strictly essential, but are very useful: a hairdryer speeds up the painting process, and saves you the tedium of waiting for washes to dry before adding further colours, and small natural sponges, which most artists have to hand, serve a three-fold purpose. You can use them for general cleaning up after a painting session, for removing areas of colour when you make a mistake, and for lifting-out techniques (see pages 26–27). Most art shops sell these, but make sure they are good quality – some can be rather hard and scratchy.

PLASTIC WATERPOT WITH NON-SPILL LID

COLLAPSIBLE WATERPOT

THE PAINTING COURSES

The book is structured around a series of six courses, each of which comprises a series of exercises and a painting project for each weekend (or indeed any two days of the week for those who don't work). On Saturday (or day one) you will practise techniques such as brushwork, laying washes, working wet-into-wet, mixing colours and achieving texture effects, and on the following day you will complete a painting project.

Some of the early exercises are aimed specifically at the beginner, so those with some experience may choose to move straight on to the project painting. In each case, the finished painting is shown on the first page, together with a photograph of

the view or set-up the artist originally worked from. This is followed by a series of photographs and captions explaining each stage in the painting, and to help you achieve the correct colour mixtures, each one is accompanied by a colour swatch and a palette of mixed paint. Copy the painting project using the information provided – then if you want you can go on to paint your own picture, following the artist's technique but using a photograph or sketch of your own as a starting point. But a word of warning: copying another artist's work is fine for learning purposes, but never try to sell such a copy or pass it off as your own, or you could find yourself in breach of copyright laws.

Each of the six courses opens with a two-page 'gallery' showing works on the same theme by a variety of different artists. These are intended for additional inspiration: while the courses focus mainly on technique, the gallery pages will give you ideas on composition and choice of colours. You may find it helpful to flick through the book first, looking at all the finished paintings before buckling down to the courses.

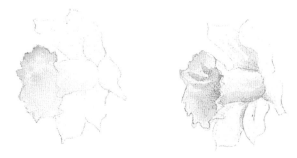

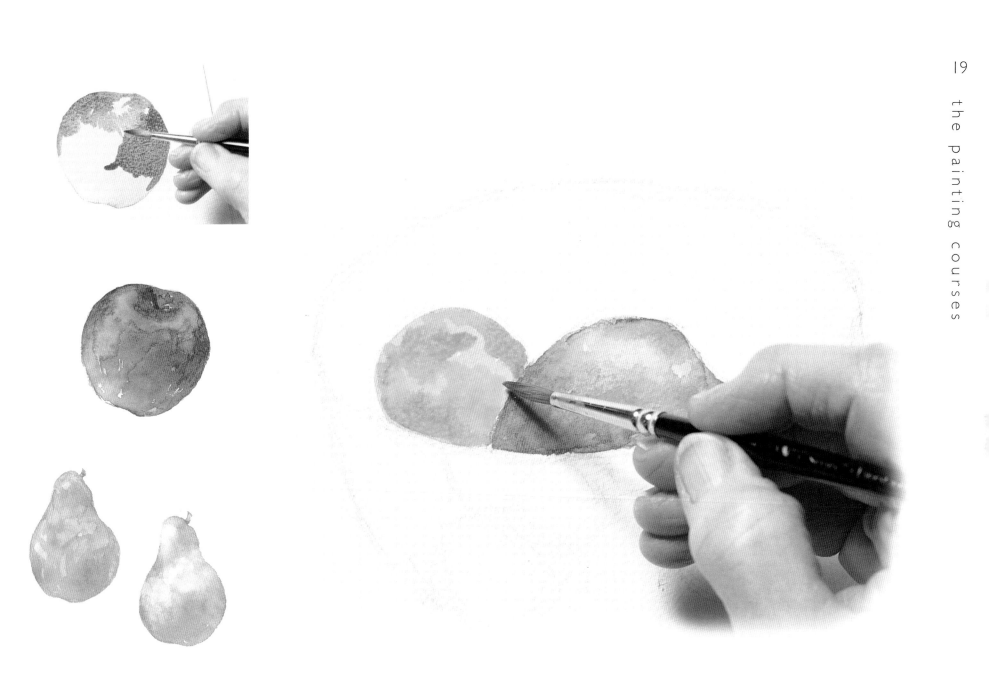

Land and Sky

In the exercises and painting project of this first course you will be practising techniques for painting skies, but don't let yourself get so carried away by cloud shapes and colours that you give them too much importance. Aim always to create a firm relationship between sky and land, as the artists have done in these paintings. For example, if you can bring some of the sky colours into the land, or repeat shapes of clouds in trees or hills, your paintings will have more unity.

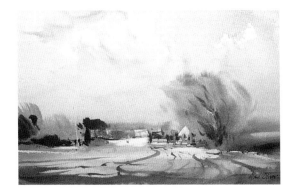

Norfolk Farm, Alan Oliver

The primary role of the sky here is to reinforce the impression of the flat, windswept landscape, and it has been treated very lightly, with the cloud shapes suggested with just a few well-placed highlights and touches of warm-coloured shadow. The tree has been worked wet-into-wet to create soft edges that merge gently into the sky, and the feeling of space is emphasised by the crisp curving lines that lead into the picture from the foreground to the buildings.

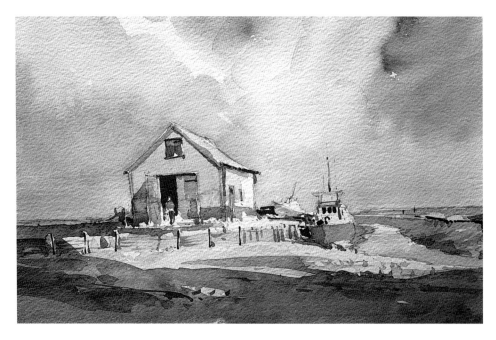

Thornham Break, Alan Oliver

The building (which is the focal point of the composition) breaks the horizon line, with the clouds pushing downwards towards it. At the top of the sky the white streak echoes the pale colours of the building and patch of sunlit grass, while darker patches at top right pick up the boat's colour.

Swans at Laleham, Jill Bays

The artist has achieved compositional unity in this lively and attractive painting, both by repeating colours from sky to land, and by using the same loose, free technique all over the picture. She has aimed at a broad impression, and has resisted any temptation to treat the foreground swans in more detail than the sky and trees. Instead, she has lightly suggested the shapes of the birds' necks with sketchy pencil lines.

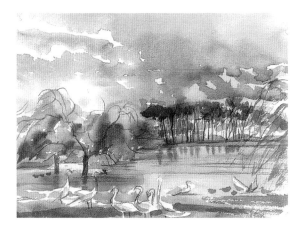

Kweilin Image, Mary C. Chan

In this painting, the artist has freely invented cloud shapes that mirror those of the mountains, creating a strong sense of drama and movement. She has used a quiet range of greys for the clouds, in contrast to the vivid colours of the mountains, relying on the repetition of shapes to unify the composition.

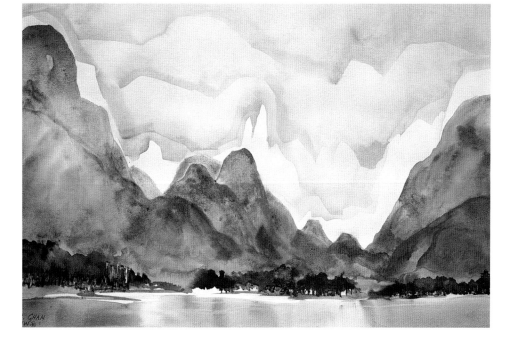

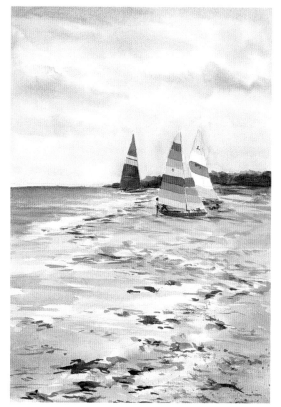

Florida Gulf, F. McIlvain

The sky doesn't play a major role here, but it is nevertheless important to add to the atmosphere of the scene as well as to provide a backdrop to the colourful sails. The quiet greenish-greys of the clouds and the blue-greys of the water are the perfect foil for the reds and yellows. Notice also how the greys in the foreground and water are used again on the left-hand sail, while the greys on the right repeat the greens of the headland, thus making colour links between each area.

flat and graded washes

The first two groups of exercises concentrate on laying washes, which are the basis for most watercolour work. Washes can cover a large area or a small one. They are frequently used for skies and for blocking in the first colours in a landscape, but you can also lay more selective washes for individual parts of a picture, such as walls or a group of trees.

working method

Washes can be laid with a round brush, a good choice for small areas, but a large, flat brush is best for covering the whole of the paper, and you may find it easier to stand, to get a free, loose arm movement. Mix up a good quantity of paint in advance because if you have to stop to remix halfway through, the wash will have begun to dry, which may result in a hard line. Colours become much lighter when they have dried, so try them out first on a spare piece of paper.

exercise 1

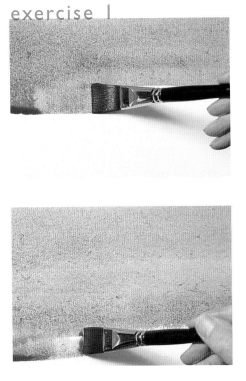

MIXING COLOURS FOR WASHES

Put a generous amount of water into one of the largest wells of your palette or paintbox lid, and then gradually add colour, stirring well each time. When you have achieved sufficient depth of colour, mix the wash once again before loading your brush. Dip the brush right in; don't just take up a little colour on the tip.

flat wash on dry paper

Prop the board up at a slight angle to encourage the paint to flow down the paper. Fill the brush well and sweep it right across the paper in one continuous stroke. Dip the brush into the paint again and repeat the process as you work down the paper, letting the brush just touch the band of colour above it each time. Use a clean, damp brush to remove any pools of paint at the bottom of the wash.

exercise 2

flat wash on damp paper

Damping the paper helps the colour to spread more evenly, as the separate brushstrokes will run together. This is the method to use if you intend to work the first stages of the painting wet-into-wet. Go over the whole of the sheet with a sponge or large brush dipped in clean water first, then work in the same way as before. Lay the board flat and leave to dry.

exercise 3

graded wash

Skies are lighter at the bottom, so you will sometimes need to lay a wash that varies in tone. You must work on dry paper for this method, because on damp paper the lines of dark colour will flow into the paler ones. Lay the first line of colour, then dip the brush into clean water before refilling it with paint; this will dilute the paint by the same amount each time you lay a line of colour so that the wash becomes progressively paler.

24

variegated washes

working method

Variegated washes are most often worked on damp paper, simply because they form the first stage of a wet-into-wet painting, but you can also use dry paper, working as for a flat wash but laying separate bands of colour. Another method is to lay a flat wash on dry paper and then drop more colour into it while the paint is still wet. If you do this, however, you must use stronger mixtures for the new colours; if you try to work light (more watery) colour into dark, the water will flow outwards, causing the blotches known as backruns (more about these on page 60).

A variegated wash is one that contains more than one colour. This type of wash, where the colours softly blend into one another on the paper, is also known as working wet-into-wet, and is especially useful for the first stages in landscape painting.

exercise 4

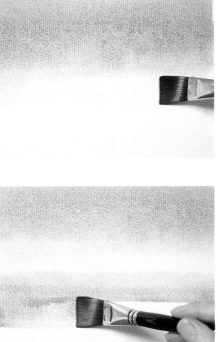

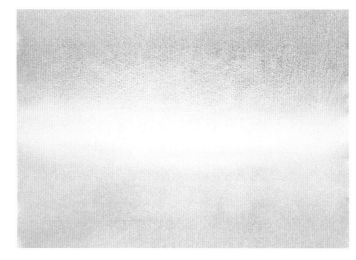

two-colour wash

In a seascape, you may see variations between the sky and sea colour, requiring two separate colours in the first wash. Here, phthalo blue, a cool greenish blue, is laid beneath ultramarine. Mix up the colours you want to use, lay the first colour, grading it with a little water at the bottom, then add the second colour. To achieve a more gentle gradation between the two colours, omit the water stage.

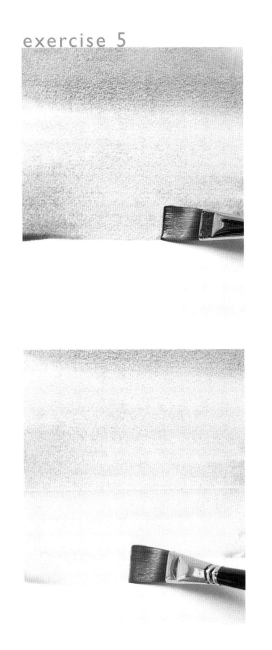

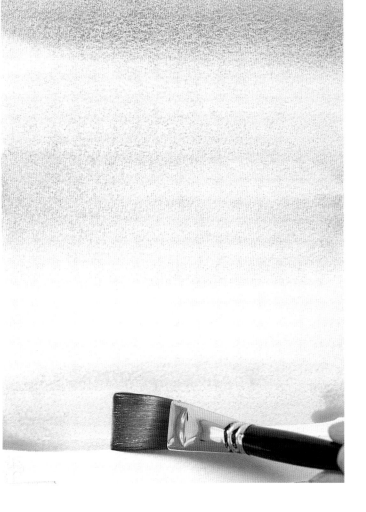

multicoloured wash

In a landscape you may want a range of colours for the first wash, changing from blues in the sky to greens or yellows for the land area. Here, five colours are used: ultramarine, phthalo blue, violet (alizarin crimson mixed with ultramarine), yellow ochre and sap green. Mix up each of the colours with approximately the same amount of water, then damp the paper and lay them on in bands, washing the brush between each colour.

26

lifting out

This technique is one used by most watercolour painters to get around the difficulty of 'painting' white. It has many variations, and is fun to practise. The idea is to remove paint before it has dried, making soft-edged, irregularly shaped highlights. You will be able to create amazingly life-like clouds in a short space of time. The method is also useful for making soft highlights on distant trees, on leaves in a flower painting, or on fruit in a still life.

what to use

You can lift out the wet paint with various materials. For simple white wind clouds you can just sweep a damp brush, small sponge or piece of cotton wool across the paper. For tiny specks of cloud you can dab with a cotton-wool bud. For gentle variations in an overcast sky you can dab into a grey wash with a sponge or tissue. Crumpled kitchen paper lifts paint unevenly, leaving little patches of colour behind. Try all of them and make a note of the best effects.

exercise 6

white wind clouds

Lay a graded wash of ultramarine on dry paper. Before the paint dries, dip a flat brush into clean water and squeeze the surplus water off, so it is just damp. Use the brush on its side to create thin cloud shapes, taking it across the wet wash, following the direction of the clouds. Make the brushstrokes strong and positive, varying the pressure a little for tonal variation.

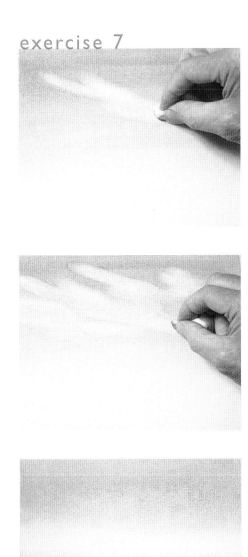

soft wind clouds

Thin clouds and vapour trails gradually spread and thicken as they accumulate moisture, and you can render these softer effects by lifting out with cotton wool. As before, lay a graded wash of ultramarine, then take a small piece of dry cotton wool across in the direction of the clouds. Work over the whole cloud area, lifting out more colour in places but leaving some of the blue wash showing to suggest the shadows.

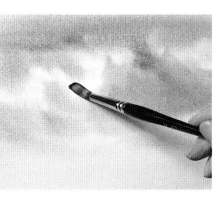

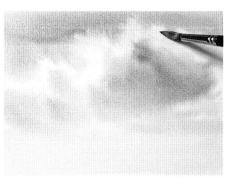

windblown cumulus clouds

Both cotton wool and brushes are used for this more intricate cloud effect. Wet the paper, then paint ultramarine at the top of the sky. Lift out the cloud tops with cotton wool, paint the clouds with mixtures of ultramarine and alizarin crimson, then use a brush to lift out more colour on the tops. The brushstrokes used for both painting and lifting out should follow the same direction for the shapes to look consistent.

exercise 9

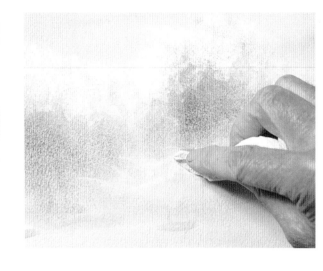

overcast sky

For complex cloud formations, where the tops of the clouds have a crumpled look, with only tiny areas of white, kitchen paper is the best lifting-out implement, and you will need to lay on at least two layers of preliminary colour. Start with a light wash of yellow ochre on damp paper. Then mix up a grey from burnt umber and ultramarine, and squiggle on the main cloud shape, varying the brushstrokes from loose curves at the top to small, straight strokes at the bottom. When the colour has begun to spread and diffuse, dab into the tops of the clouds with kitchen paper folded into a pad, using it lightly so that little patches of the original colours remain. Lift out the highlights on the lower cloud in the same way, but with the paper refolded to form a straight edge.

SKY EFFECTS

The colours of skies and clouds vary enormously depending on the position of the sun. At midday the blue of a sky is at its most intense, and clouds will reflect this, so their shadowed undersides will be purplish or blue-grey. A low evening or early-morning sun changes the picture dramatically; clear sky becomes paler, often with a green or yellow tinge, and clouds may have yellow highlights and brownish shadows. The colours are also affected by distance. Skies, like all landscape features, are subject to the laws of perspective, which make distant objects appear smaller in size and more muted in colour, with the minimum of tonal contrast. The area of sky directly overhead is nearer to you than the sky on the horizon, which becomes paler as it recedes from you. It may also change colour quite significantly, grading from a pure, rich blue to a delicate blue-green. In the same way, clouds are smaller and paler on the horizon. It is useful to remember these facts if you are painting from a poor photograph.

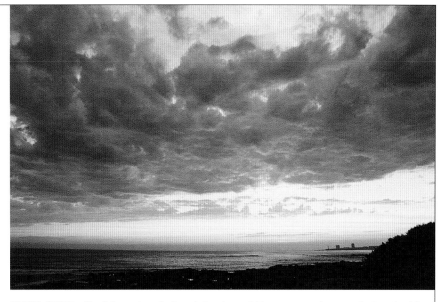

SUNSET CLOUDS Cloud formations lit from below by a sinking sun are often amazingly colourful. Sadly, these effects last only a very short time, so reach for your camera when you see one.

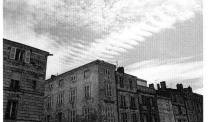

WHITE CLOUDS These thin, high cirrus clouds do not have the three-dimensional mass of other clouds, and so remain white or near-white, though they may reflect some colour from a setting sun.

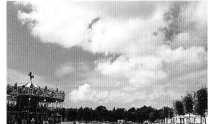

PERSPECTIVE This photograph shows the perspective effects of diminishing size and tonal contrast very clearly. It was taken at midday, with little colour other than a brownish-grey in the cloud shadows.

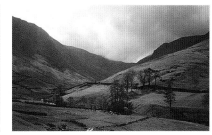

THICK CLOUD COVER A thick layer of rain-bearing cloud obscures the sun so thoroughly that there is little light to reflect, thus little colour. It is sometimes necessary to cheat in a painting, bringing in purples and yellows.

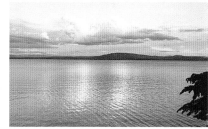

REFLECTED COLOUR A low sun gives a marvellous glow to the clouds, with colours running through from pinkish yellow on the sunlit tops to deep blue-greys and mauves on the shadowed undersides.

summer landscape

simple washes and cloud shapes

You are now ready to start your Sunday painting. *Summer Landscape* by Alan Oliver uses the techniques you learnt in the Saturday land and sky exercises to create a strong sense of space and convey a range of lighting effects. Base your painting on Alan's photographic reference, observing how he has altered various features to make a livelier, more dynamic composition. You will be working wet-into-wet for the first stages, which involves moving fast, so if the phone rings, ignore it. Alan's tip to avoid panic is to mix the colours in advance.

the view – and how to interpret it

This landscape has potential for a painting, but the foreground is dull, and the trees not large enough to play much part in the composition. Alan has thus used his judgement, together with his memory of similar landscapes, to make various changes. He decided to enlarge the trees so that those on the left break the horizon line, and has added emphasis by bringing in a touch of red-brown behind them. Most important, he has altered the foreground from a dark green field of crops to a pale yellow hay field, with a suggestion of diagonal perspective lines leading from foreground to middle distance. These lead the eye into the picture to give a feeling of space.

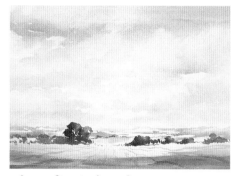

the finished painting

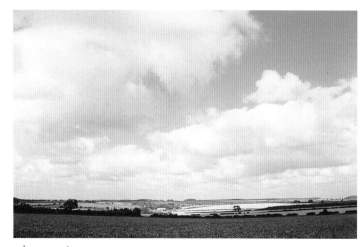

the view

YOU WILL NEED

Colours
ultramarine
phthalo blue
sap green
burnt umber
alizarin crimson
yellow ochre
cadmium red

Brushes
No. 10 or 12
round brush
20mm (¾in) flat
brush

Paper
425gsm (200lb)
NOT surface paper,
unstretched or
300gsm (140lb)
NOT surface paper,
stretched
2B or 4B pencil
kitchen paper

Even for a simple landscape like this, it is vital to place the main elements and to decide on the position of the horizon before you begin to paint. In this case it is especially important because the composition is planned at the drawing stage. Alan makes very loose lines, holding the pencil at the end – if you hold it near the lead, the lines will become tight and fussy.

step 1

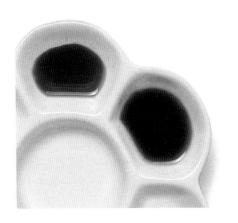

1 Begin by damping the paper, which allows more time for wet-into-wet work, and then lay washes of colour for the sky with the flat brush. The colours used are ultramarine at the top of the sky, with lines of phthalo blue below.

step 2

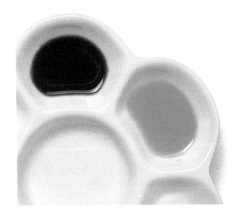

2 With the paper still wet, lay a wash of yellow ochre over the whole of the land area. Next, load the flat brush fully and lay on a mixture of sap green and burnt umber in the foreground. Wash the brush between colours.

step 3

3 Because you are working fast, and the paper was well damped in advance, the washes for the sky should still be wet enough to enable you to lift out the tops of the clouds with crumpled kitchen paper. For the next stages the paper needs to dry out a little, so it is left for about ten minutes – a hairdryer can be used to speed up the process.

step 4

4 Now begin to build up the cloud effects using different tones of a grey-violet mixed from ultramarine and burnt umber. Use the large round brush, holding it well away from the bristles and lightly 'doodling' with the tip, and then soften the brushstrokes with clean water.

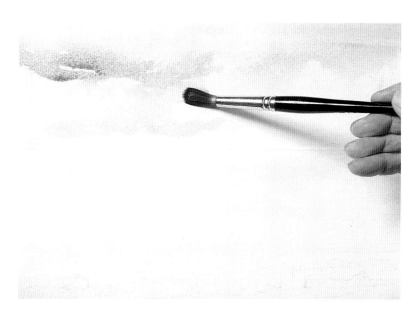

step 5

5 Continuing with the same ultramarine and burnt umber mixture, work gradually down the sky area, building up the dark undersides of the clouds. Vary the tones by adding more water to the mix where the grey blends softly into the white.

step 6

6 Take care to make the brushmarks smaller for the clouds above the horizon, and use a paler version of the grey mixture. Create a lively feel, giving the impression of the sky's movement, by varying the brushmarks; here the hairs of the brush are pushed into the wet paint, making a soft blob.

step 7

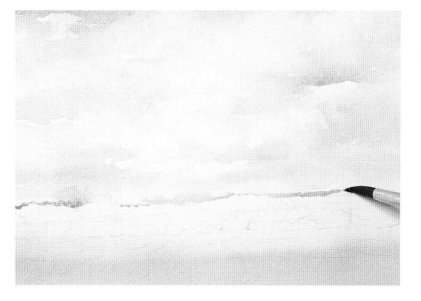

7 At the bottom of the sky, add a little extra burnt umber to the basic grey mix to produce a pinkish tinge, then dry lightly with a hairdryer before starting work on the land. To create a relationship between land and sky, use a pinker version of the cloud colour, this time made by mixing ultramarine with a little alizarin crimson. To avoid an over-regular line, lightly trail the brush across the paper, holding it loosely near the end.

step 8

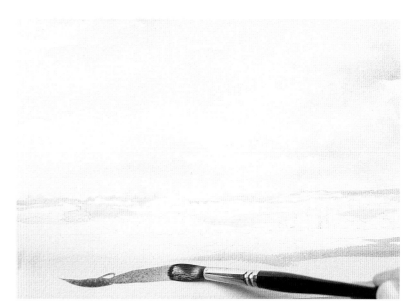

8 The distant fields are suggested with brushstrokes of a pale sap green and burnt umber mix. Use a stronger version of the same colour for the foreground shadow, keeping the brush well loaded with paint. The paper is still slightly damp, but as it begins to dry the paint will spread unevenly at the edges to give soft, irregular effects.

step 9

9 Now begin to work on the trees, starting with a dark, muted green made by mixing ultramarine and yellow ochre and then dropping in burnt umber. The trees dominate the composition because they are the darkest areas of tone, but they are not vivid in colour. If the paper is still slightly damp the paint will spread out in places, giving a contrast between soft and hard edges.

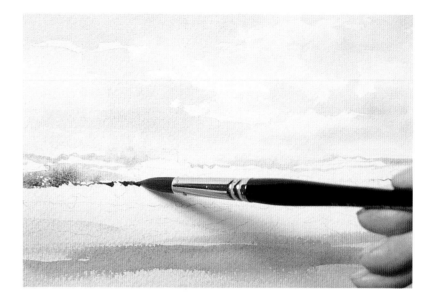

step 10

10 The final stages of the painting are done wet-on-dry. In an essentially low-key colour scheme, a strong accent is often needed to draw the eye, and the red field plays an important part in the composition. Paint this in before working on the main tree, using the tip of the brush and a mixture of cadmium red and burnt umber.

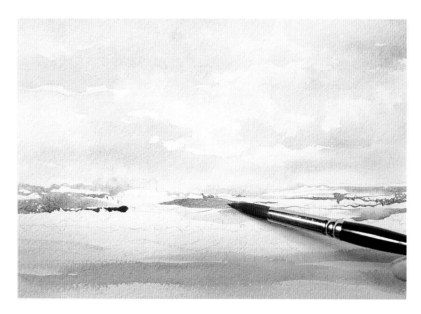

step 11

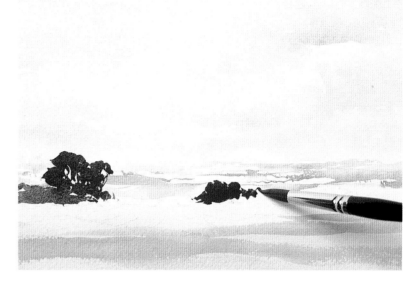

11 Continue to work on the trees, using the ultramarine/yellow ochre mix for those on the left, but changing to sap green and burnt umber for the central group. Dab lightly with the point of the brush, holding it at right-angles to the paper, and before the paint has dried, blot the light-struck areas lightly with kitchen paper.

step 12

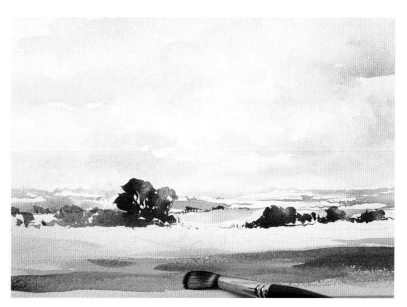

12 Little detail is needed in the foreground, but a strong tone is required to balance the trees. Darken the shadow with the same sap green/burnt umber mixture, adding one or two strokes of neat burnt umber at the sides.

step 13

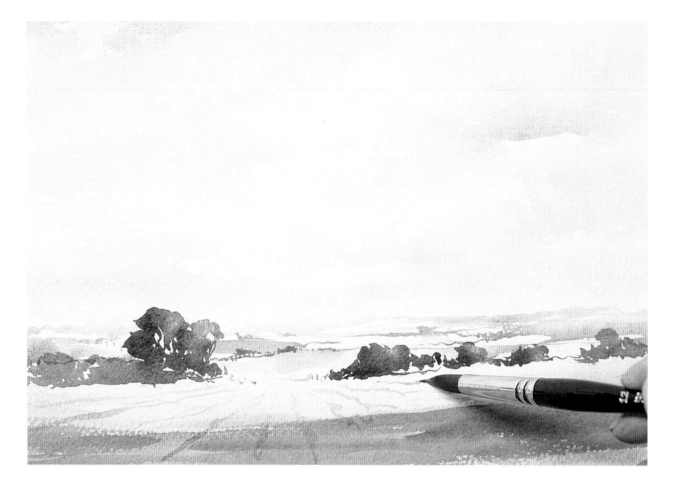

13 The final step is to add the perspective lines, taking great care not to make them too even and regular. To create the impression of the slight undulations in the land, use the tip of the brush and a paler version of the shadow colour to paint light, wiggly lines, varying the pressure so that they are thicker in some places than others.

The finished painting derives its lovely feeling of space and freshness from two main factors: the composition and the careful control of colour. All the greys and greens were obtained by mixing no more than two colours, and little or no overpainting was done – this can quickly muddy the colours. The composition is simple but effective, with the large tree and red field forming the focal point, and the land occupying one third of the picture space, a classic proportion. This was another of Alan's judicial changes; if you look back at the photograph you will see that the horizon was much lower, giving a rather awkward effect, as though the land were slipping out of the frame.

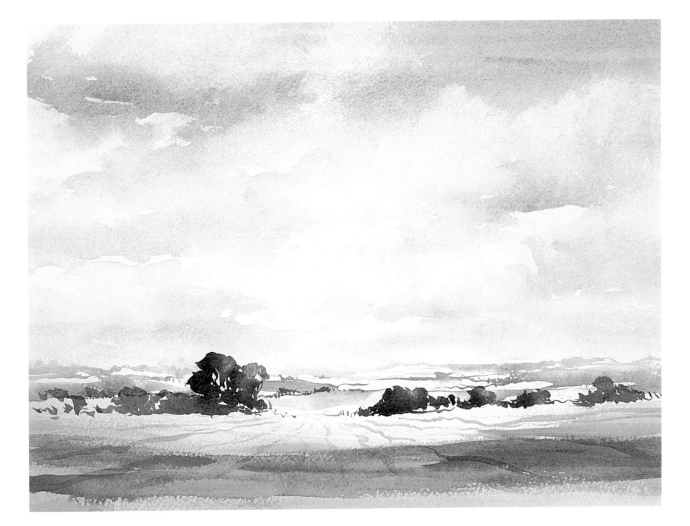

Summer Landscape, Alan Oliver

Land and Water

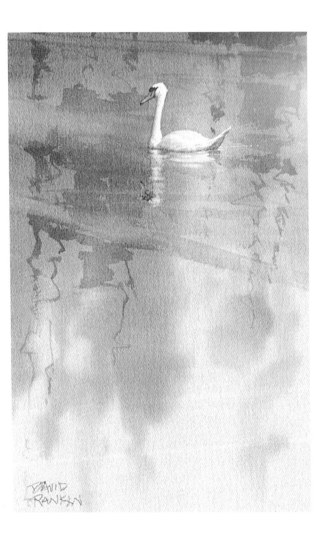

n all of these paintings featuring water and reflections, brushwork plays a vital role. But technique, although important, is only one aspect of painting, and these pictures are successful because equal attention has been given both to the handling of the paint and to the purely pictorial values of colour and composition.

Mute Swan, David Rankin

The composition has a vertical emphasis, with the focal point – the swan and its reflection – placed near the top and the reflections leading up to it. The horizontal and diagonal bands of lighter colour above and below the swan are important, as they lightly frame and enclose the bird, thus drawing attention to it.

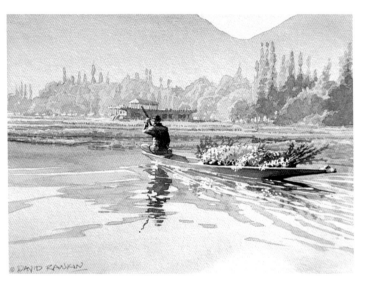

Kashmir Summer, David Rankin

The lovely shapes made by the ripples lead the eye up to the flower-laden boat, the focal point (centre of interest) of the composition. The red roof of the building on the shore picks up the red of the flowers to link these two areas of the painting.

Waiting Till It Lifts, James McFarlane

This painting, carefully structured and beautifully painted, has an additional 'narrative' element, that is, it hints at a story. Besides enjoying the painting for its own sake, we are drawn in on another level, and can imagine the boat owners waiting impatiently for the mist to clear.

South Bristol, Maine, Carlton Plummer

The first thing you notice is the handling of the water, which has been built up in a series of overlaid washes and brushmarks to create a lively network of shapes and colours. But the picture derives much of its impact from the colour scheme, which is based on two of the complementary, or opposite, colours, blue and orange. These are repeated with slight variations throughout the picture, and the green hill in the background has been deliberately muted with touches of blue so that it does not detract from the main colours.

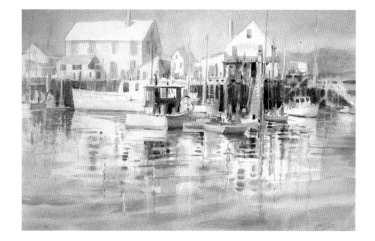

Lake Geese in the Sun, Nita Engle

This is an example of the use of harmonious, or closely related, colours such as blue and mauve, yellow and green, or in this case yellow and orange – those that are close together on a colour wheel. These colours always create a gentle, peaceful effect because there are no strong contrasts. The artist has brought in just a touch of quiet contrast in the foreground, where the water reflects the blue of the overhead sky.

water in
movement

T he effects you see in moving water, or on a lake whose smooth surface is broken by a gentle breeze, are very exciting, with the ripples making lovely patterns of light and shadow. Paint these with strong, calligraphic brushstrokes, and use masking fluid for the highlights.

'negative' brushwork

Masking fluid, a viscous substance that is applied before laying on colour, enables you to create highlights by preserving the white of the paper under a rubbery resist, which is removed once the paint has dried. The traditional method of reserving white areas is by painting around them, but it is difficult to achieve the distinct but subtly varied shapes you see on the tops of ripples in this way. With masking fluid you can make strong, calligraphic marks that describe the shapes. Try out different strokes with masking fluid, and then echo these with 'positive' strokes – that is, with the colour you put on later for the darker areas.

exercise 1

choppy water

You will see many different shapes in choppy water, from large, rounded ripples to lines and small dots in the distance. Use a round brush, which is very versatile, to lay on the fluid, varying the strokes as much as you can, and making them smaller towards the back. Wash the brush immediately; letting it dry on the brush will ruin it. Leave the fluid to dry – you can use a hairdryer to cut down drying time – and then lay washes on top; here, ultramarine is used at the top and a mix of sap green and yellow ochre at the bottom. Let the washes dry before removing the fluid, either with your fingertip or with an eraser.

exercise 2

exercise 3

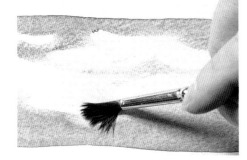

gentle swells

Elongated curves are a typical effect of gently swelling water, such as you might see at the outer edges of the wake caused by passing boats. For this, make long, continuous strokes with the round brush, leave to dry as before, and then wash over with phthalo blue or ultramarine.

softening edges

Depending on the amount of movement in the water, the light-struck tops of ripples may be hard-edged and crisp or softer, merging more gently into the shadowed areas. In the latter case you may need to soften some of the edges after you have removed the masking. To do this, apply the fluid and washes in the same way as before and then go over the edges with a brush dipped into clean water.

exercise 4

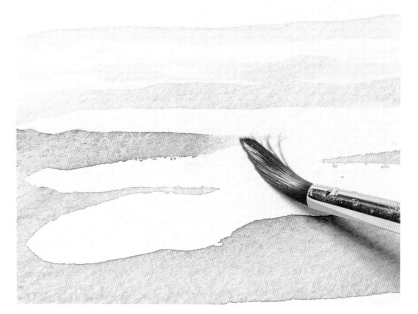

hard and soft edges

The effects of perspective cause far-off objects to appear smaller and less distinct than those near to you, so create space in your painting by softening the edges of background ripples, leaving those in the foreground as hard-edged shapes. Use larger strokes of masking fluid for the foreground and smaller ones for the distant ripples. Lay a graded wash (see page 23) with stronger colour for the foreground, then soften the edges of the smaller ripples in the background.

course 2

sparkling water

The lively shimmer of distant water reflecting tiny pinpricks of light is one of the most attractive elements in seascapes and landscapes featuring water. There are a number of ways to create these effects.

methods to use

Watercolour paper has a slight texture, or 'tooth', which is designed to hold the paint and prevent it slipping about too much, as it would on a smooth surface. This texture can be used to create what is known as 'broken' colour, where the paint lies only on the top of the grain, leaving speckles of white or of another colour beneath. You can suggest the sparkle of distant water in this way, either dragging masking fluid lightly over the surface or using rather dry paint, lightly applied. Another method is to scratch away some of the paint with a knife.

exercise 5

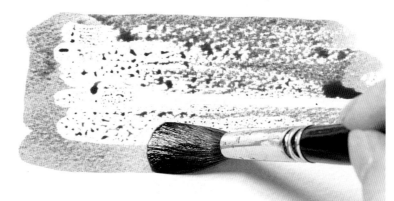

dragging masking fluid

Masking fluid is thick and rubbery, and can be painted on lightly so that it sits only on the top grain of the paper. Start at the left, with the brush well loaded, and pull it across the paper without reloading it. Allow to dry, then brush on watercolour paint to reveal the effects you have created.

exercise 6

drybrushing

This method is almost the same, but this time you use paint itself to create the broken-colour effect, with no masking fluid. Either wipe the brush after dipping it into the paint so that little paint remains on it, or work by 'starving' the brush of paint simply by not reloading it.

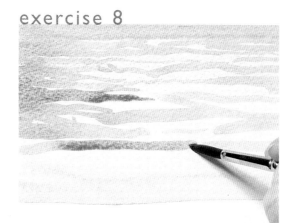

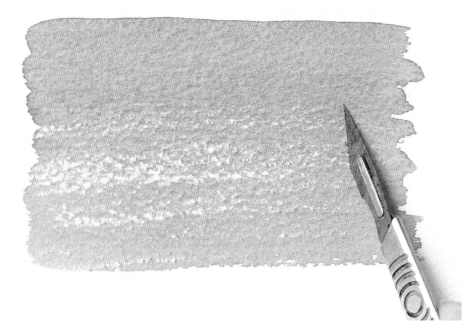

scratching back

This is a useful method to use if you have accidentally laid too flat a wash and lost the sparkle of the water. When the paint is fully dry, use the flat edge of a blade such as a scalpel or craft knife to very gently scrape off the top layer. This will scuff the top grain of the paper, so do not work over a scraped area or the paint will form unpleasant blotches.

varying the methods

In an expanse of water you may see an area of sparkling water in the distance and more pronounced light effects in the middle distance or foreground. These can be painted with small brushmarks of masking fluid, varying the direction of the strokes. This method can be combined with any of the others on these pages to give your work variety.

working
wet-on-dry

To enable your brushwork to capture the crisp-edged shapes of ripples, or reflections in a broken water surface, work wet-on-dry, letting each colour dry before adding the next, and building up a network of distinct and separate brushmarks.

looking for the main shapes

The patterns seen in the broken surface of water are very complex, so you will usually have to simplify. Try to identify the main shapes, patterns and colours. A ripple or wavelet presents a series of inclined planes, which reflect other colours as well as that of the sky, with some areas in deep shadow. Bear in mind also that no two ripples are the same, so try to express this variety by the way you use your brushstrokes.

exercise 9

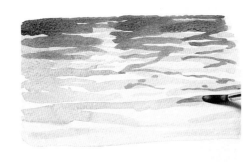

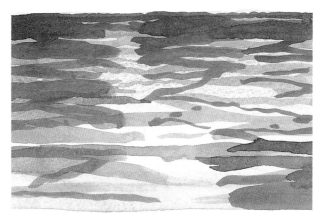

building up light and shadow

Lay a pale variegated wash (see pages 24–25) of blue grading to yellow, and leave it to dry. Then begin to build up with loose brushstrokes of a mid-blue, varying the marks from long, straight, sweeping strokes at the back to curves and squiggles. Again leave to dry before adding the darker colours, placing them so that they overlap the first and second colours in places but being careful not to obscure the earlier marks – aim for a busy effect in which each brushstroke plays a definite part.

REFLECTIONS

The flat surface of water acts like a mirror, so that any reflected landscape feature, such as a tree or hill, is the same height and width as the object that casts the reflection. But, of course, the reflection is seen in reverse, so that the reflection of an angled object such as the prow of a boat runs at the opposite angle. Reflections in choppy water are more complex because they are broken up and scattered by the 'hills and troughs' of the ripples, spreading out sideways or downwards to form small patches or lines of colour. Observe these shapes carefully, and use your brushwork to describe them, varying the marks from linear squiggles to square marks or rounded blobs.

The reflection is completely obscured at the top, because the ruffled water does not present sufficient reflective surface.

The reflections of the posts are spread out sideways by the gently rippling water. Notice how the reflected sky colour is darker towards the front.

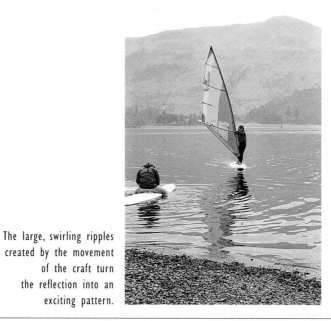

The large, swirling ripples created by the movement of the craft turn the reflection into an exciting pattern.

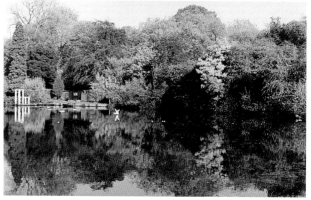

The still water provides an almost perfect mirror image, though with a slight blurring.

course 2

Sunset over Jackson Lake masking fluid and water effects

For this painting, you will have the opportunity to use the masking fluid and wet-on-dry methods in context to create a lovely evocation of light on water. Don't attempt too much detail in the water – give your brush its head to make loose, descriptive marks.

using artistic licence

Trevor Waugh decided to give additional excitement to this attractive view by bringing in a range of pinks and mauves to emphasise the sunset light, by making a stronger feature of the rippling water and by introducing a lovely shimmer effect on the distant area of water. He also played down the dark tone of the clouds, preferring a more gentle effect that does not steal attention away from the water.

Waugh used one colour, cerulean blue, that is not in the recommended palette. If you do not have this, use a mixture of phthalo blue and ultramarine instead. The effect will not be exactly the same, but the slight difference will not affect the quality of the painting.

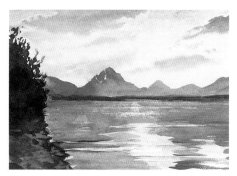

the finished painting

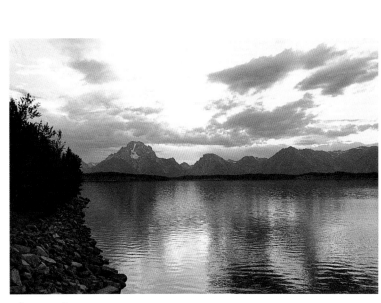

the view

A detailed drawing is not necessary, because the water occupies the greater part of the picture area, and here you will be 'drawing' with your brush. However, do make sure you draw the shapes of the mountains accurately as well as that of the tree on the left. When you have made the drawing, paint broad brushstrokes of masking fluid over the central area of water. If you are unsure of where to place these, refer to Step 8 on page 53.

YOU WILL NEED

Colours
ultramarine
phthalo blue
cerulean blue (see
page 48 for
alternative)
yellow ochre
alizarin crimson
cadmium red
sap green
burnt umber
Payne's grey

Brushes
large round

**Paper and
other
equipment**
425gsm (200lb)
NOT surface paper,
unstretched or
300gsm (140lb)
NOT surface paper,
stretched
masking fluid
3B or 4B pencil

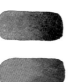

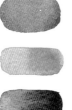

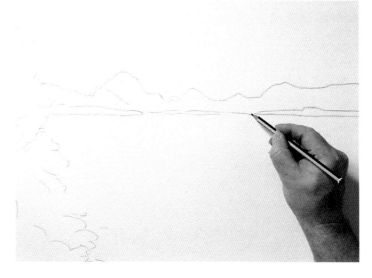

LEFT: The yellow-tinted masking fluid is the best, as you can see where you are applying it.

step 1

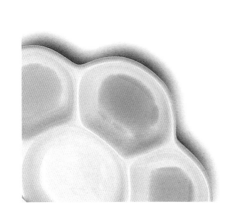

Begin by laying a very pale variegated
wash (see pages 24–25) over the whole
of the paper, starting at the top with
yellow ochre, changing to cerulean or
phthalo blue for the mountains, and
then returning to yellow ochre with
a little added alizarin crimson for the
water area.

step 2

2 With the first washes still damp, work a
little more blue into the hills, using
phthalo blue and Payne's grey, and paint
the top clouds with a mixture of alizarin
crimson and Payne's grey.

step 3

3 Paint the top cloud with the same
mixture but a higher proportion of
crimson and then, using the tip of the
brush, touch in the pale pink cloud with
a dilute crimson and yellow ochre mix.

step 4

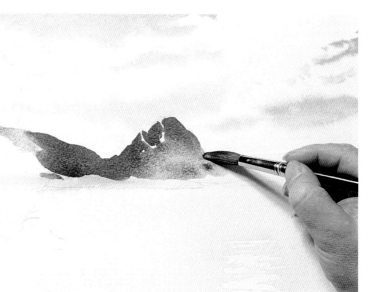

4 You will be working wet-on-dry for the
rest of the painting, as crisp edges are
needed for the mountains and the
water, so leave the paper to dry. Paint
the mountains with a mix of cerulean or
phthalo blue and Payne's grey, working in
a touch of burnt umber and alizarin
crimson in the centre, and leaving small
lines of white for the snow.

course 2

step 5

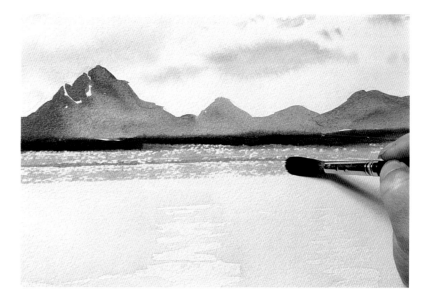

5 Paint a band of strong, dark green-brown across the bottom of the mountains, using a mix of Payne's grey, sap green and cadmium red. Then work on the distant water, using the dry-brush method and the same blue-grey used for the mountains.

step 6

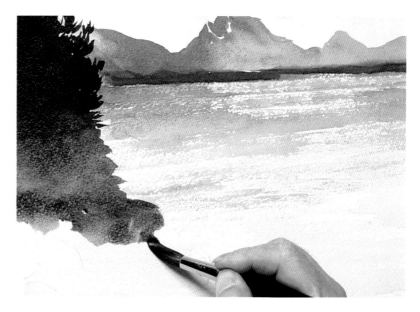

6 Build up the water surface with further brushstrokes of this grey in varying strengths using the dry-brush method, then paint the tree and rocks, working colours together on the paper. Start with an olive green made from sap green, burnt umber and Payne's grey, then add cadmium red to the mixture and work in the resulting red-brown, suggesting the foliage by pulling the paint out at the edges.

7 While the paint in this area is still wet, touch in small shapes to suggest the shadows of the beach stones, repeating the colour used for the dark band of land in Step 5 to create links across the composition.

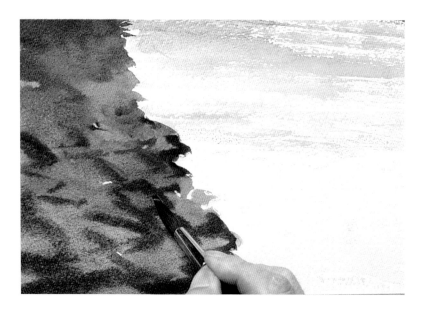

8 Remove the masking fluid, soften the edges of the background ripples with water, and lay on a wash of pinkish-orange mixed from alizarin crimson and yellow ochre.

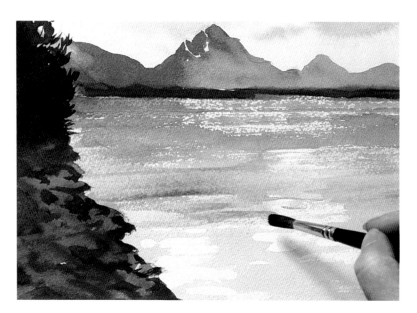

step 9

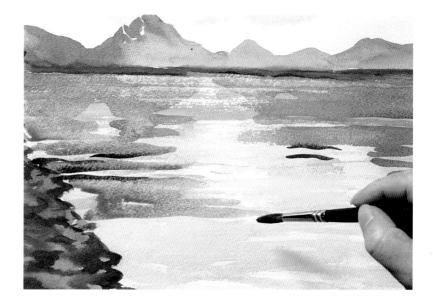

9 Add more of the dilute crimson/yellow ochre mix to the water and continue to build up the ripple effects, painting the shadows with firm strokes using a well-loaded brush. Vary the colours from Payne's grey alone to mixtures of grey and phthalo blue, and grey and yellow ochre. In the centre, where the water reflects the sunset, add the mauve-greys and pinks used for the clouds.

step 10

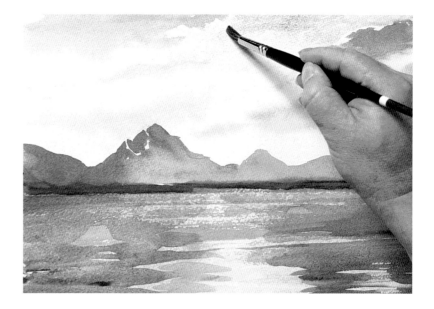

10 Finally, work a little more colour into the clouds with a mixture of ultramarine and alizarin crimson in varying strengths, and then add a patch of pure cerulean blue at the top, leaving a line of highlight around the top of the cloud at top right.

The use of a range of colours in close harmony has captured the tranquillity of the scene very successfully. Colours that are close together on a colour wheel, such as these blues, mauves and pinks, are described as related, or harmonious colours, and they always create a gentle effect when placed together. Paintings in related colours can sometimes look a little bland, but here the purity of the colour and the bold brushwork 'lift' the painting and provide an element of excitement.

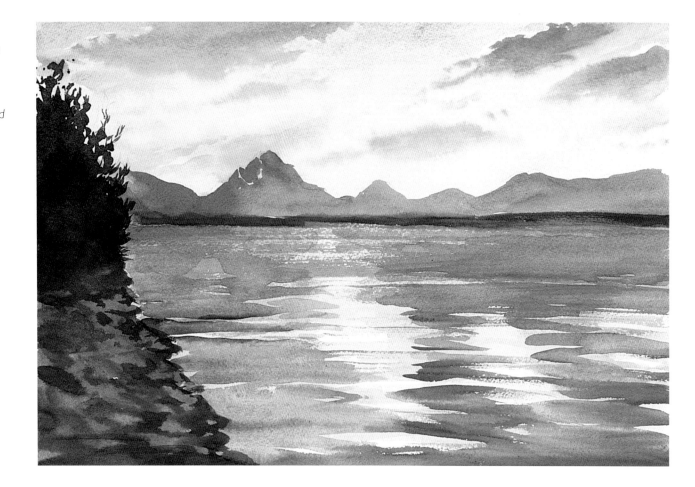

Sunset over Jackson Lake, Trevor Waugh

Trees

The beauty of trees is that they provide so many different options. You can paint bare winter trees, lush summer ones, glowing autumn foliage or delicate spring growth, and even in the same season there are endless choices to be made and different effects to exploit. You might decide to focus on just one part of a tree, such as a trunk with roots or a clump of foliage, or you might make colour or shape your main theme instead.

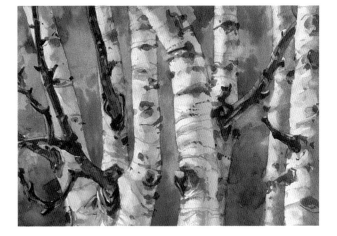

Wyoming Birch, Karen Frey

The trunks of silver birch trees are the most noticeable thing about them, perhaps more interesting than their foliage in pictorial terms, and the artist has decided to exploit the lovely bark patterns by taking a close view. She has given a sense of space and depth to the composition by hinting at more distant clumps of trees in the background, and by bringing the dark branches out to the front of the picture.

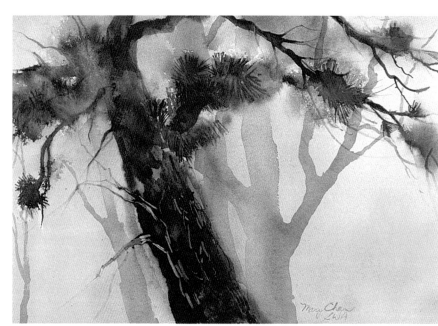

Old Pine,
Mary C. Chan

This painting also focuses on the trunk of a tree, but the effect is very different, obviously inspired by Oriental paintings. The composition is extremely powerful, with the trunk making a strong diagonal from bottom to top, balanced by the clumps of foliage and the blue-grey tree shapes behind.

Fall Colours,
David Becker

Colour is the theme of this painting, and the artist has avoided painting the foliage in detail. This has been worked largely wet-into-wet, contrasting with the crisp wet-on-dry treatment of the trunks and branches. A touch of blue-green has been brought in behind the trunks and above the foliage on the right, providing essential contrast for the dominant oranges and yellows.

Catalina Beach, Hal Scroggy

This painting is unlike the others on these pages in that the trees are not the focal point, but have been used as a frame for the white boats and stretch of blue water. This compositional device was often employed by landscape painters of the eighteenth and early nineteenth centuries, notably the French artist, Camille Corot.

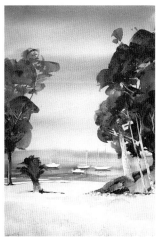

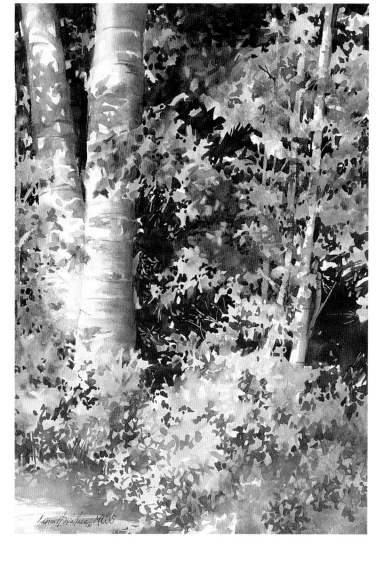

Birch Colours,
Lennox H. Wallace

The sparkling effect of sunlight on autumn colours is wonderfully conveyed through small, separate brushstrokes worked mainly wet-on-dry over looser washes. Notice the strong light-dark contrasts, ranging from near-whites through yellows and rich reds to near-blacks, which throw the pale trunks into relief.

brushwork

D istant trees can usually be treated quite broadly, painted in one- or two-colour washes, or worked wet-into-wet. However, if they are relatively close you will want to engage with them in more detail, giving an idea of the structure and type of foliage. You can do this through developing your brushwork technique to make marks that describe the foliage effectively.

getting to know your brushes

Although you only have two main types of brush in your basic recommended kit, you will be surprised by how many different types of mark you can make with them. Round brushes are the most versatile, giving you a range of marks from tiny dots and dabs made with the tip to large, rounded blobs and long, sweeping or curving strokes. Flat brushes are also useful as you can make narrow, linear strokes with the end of the brush, ideal for trees such as cedar or Scots pine. Practise making different marks that describe various types of foliage.

exercise 1

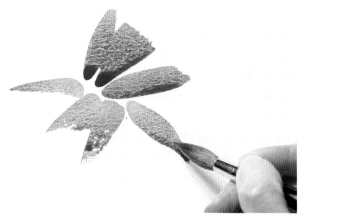

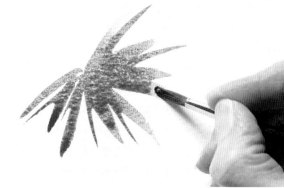

round brushes

Start with the large round brush, loading it well and making pointed lozenge shapes by drawing the stroke out towards the tip. A variation of this is to work upside-down, beginning with the point and letting the paint collect at the bottom so that it forms a pool. Next, try the smaller of the round brushes to make spiky marks. You can create tonal (light-dark) variation by letting the paint pool in places, and allowing the marks to become fainter at the edges simply by not reloading the brush.

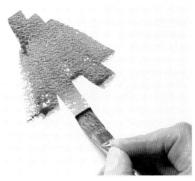

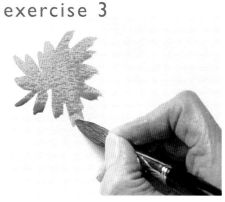

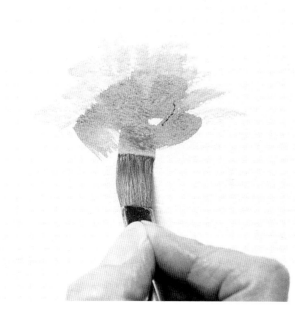

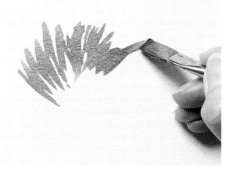

flat brushes

You cannot make so many different marks with flat brushes, but the typical large, square-ended marks made by dragging the brush towards you are useful for foreground grass or for more distant trees. Practise these strokes first, and then turn the brush on its side to produce curved or straight linear strokes.

choosing the right marks

Once you have become familiar with your brushes, and confident of controlling them, you will be able to choose the right kind of brushstroke for the subject. If you have some good photographs of foliage, or a book about trees, try describing foliage with a series of 'one-stroke' marks, starting with the large and small round brushes and then the flat.

60

course 3

wet-into-wet effects

Background trees, those in the middle or far distance, do not require detailed treatment; indeed, you can seldom see much detail. These can be worked wet-into-wet, by laying a wash and dropping further colours into it. But pay attention to the main shape; there is a handy guide to tree shapes on the opposite page.

working method

If you only want to work wet-into-wet for small areas, such as one tree or a group of trees, you can either damp the paper in this area or lay the first colour on dry paper and put in the other colours immediately. An important thing to remember about wet-into-wet is that if you drop in a lighter colour, with a higher water content, the water will flow outwards, causing backruns. These, although seen by some purists as mistakes, can be useful, and artists often induce them deliberately to suggest shapes.

exercise 4

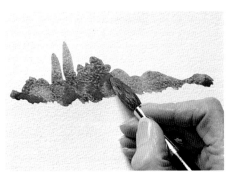

dropping in colours

Draw the main shape of the tree or group of trees and lay a loose wash in fairly dark green; here, a mix of viridian and Indian yellow with a touch of ultramarine is used. Let the paint pool in places to create darker areas, then immediately drop in a strong yellow-green mix with the tip of a large round brush.

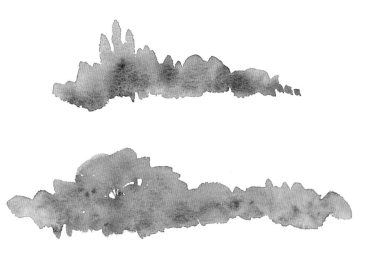

TOP AND ABOVE Working wet-into-wet always carries an element of surprise. Because the paint goes on moving until it has dried, you cannot be certain of the effect it will make.
RIGHT The dried backrun.

exercise 5

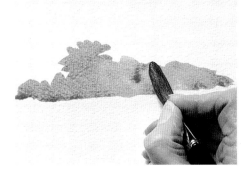

creating backruns

Backruns cannot be controlled precisely, but it is exciting to try out the effects you can achieve in this way. Lay a mid-toned wash of sap green, then drop in a more watery mix of the same green plus yellow ochre. The backrun will begin to form as the paint dries, creating jagged edges suggestive of the boundary between two clumps of foliage or the line or dark shadow down the side of a tree.

TREE SHAPES

Even when trees are quite distant, and you cannot see the foliage clearly, you can usually recognise them by their outlines. For example, the spiky shapes of Lombardy poplars, the dense, spreading canopy of an oak tree, or the ragged foliage clumps of a Scots pine on its tall, slender trunk can all be easily identified however far away they are. So, before attending to the detail, look for the main shape, and if you are unsure about proportions, measure them with a pencil held up at arm's length. We think of trees as basically tall shapes, but some are almost as wide as they are high.

Look also for the relationship of the canopy to the trunk, and the way the foliage grows, arranged in clumps at the ends of the branches. If the canopy is not dense, patches of sky will be visible between these clumps, and also near the trunk, where there is less foliage. These 'sky holes' are very important, so when you make your initial drawing, mark them in so that you can reserve small shapes of the sky colour.

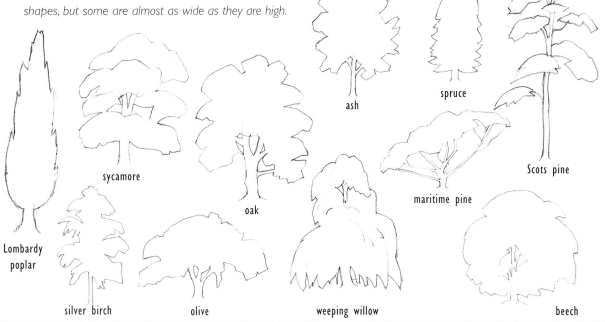

course 3

building
up

order of working

All watercolours are worked in stages, from light to dark, with the effects built up in several layers. For a clump of foliage you would usually begin with a light wash or a series of brushstrokes, letting the first colour dry and then adding further strokes. Small details such as twigs are added last, also wet-on-dry. But you may decide to work a large tree trunk entirely wet-into-wet to contrast with the crisper treatment of the foliage, in which case you would do this in the early stages before building up the foliage.

The kind of brushwork you have practised (pages 58–59) is often the last stage in a painting, with the main colours first established with washes or wet-into-wet applications. Try to vary the techniques and the brushwork to give your painting more interest.

exercise 6

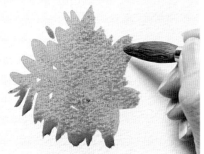

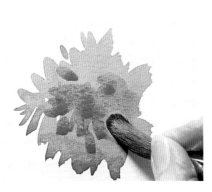

foliage wet-on-dry

Start by establishing the main shape of the tree or clump of foliage, letting the brushmarks show at the edges, then leave this first layer to dry – use a hairdryer if you are impatient. Add a second layer of brushmarks, using the same brush as before and making similar marks but varying their size and direction. Then build up the darks with more brushmarks. It is best not to work more than three layers, or four at the most, or the colours may become muddy.

exercise 7

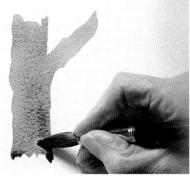

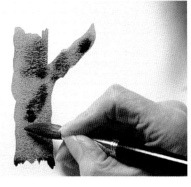

tree trunks

Large tree trunks often show strong gradations of tone, but without hard boundaries between dark and light colours. Wet-into-wet is the ideal technique for these soft effects. Using a large round brush, lay an all-over colour on dry paper, then drop splodges of darker colour into it. You can use a variety of colours for wet-into-wet, such as blues, blue-greys, purples or deep greens.

exercise 8

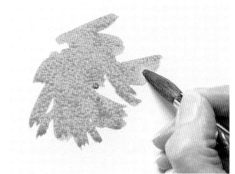

exercise 9

small branches

Small twigs and branches can be painted either wet-into-wet or wet-on-dry, depending on whether you want them to stand out clearly or merge into the greens of the foliage. For the wet-into-wet method, work in the same way as for the tree trunk, but use a smaller brush for the twigs. For the wet-on-dry twigs, use the same brush, making wiggling lines that vary slightly in thickness.

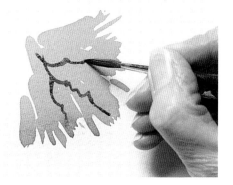

alternative methods

If you have a rigger brush you may find it useful for painting small twigs. These brushes enable you to make sensitive, somewhat calligraphic marks, changing from medium thick to very thin in the course of one brushstroke. You can also use a rigger on its side to flick on small straight lines.

Another method for the smallest twigs is simply to draw them with a soft pencil. This is especially useful for winter trees, where the network of twigs is very slow to paint with a small brush.

tree roots
and shadows

One of the difficulties encountered by inexperienced painters is making trees appear fully rooted in the ground, so look carefully at both the root system and the planes of the ground to see how they fit together. On a sunny day you will have cast shadows to help you 'root' the trees as well as aiding the composition, so make good use of these.

cast shadows

The shadows thrown by trees can be as exciting as the trees themselves, and they also help to explain and reinforce the tree shapes. If you intend to make a feature of shadows, and are painting on the spot, mark the direction of the light when you start by making a little arrow in the top corner of the picture, because the shadows will change direction as the sun moves. Some artists begin with the shadows, blocking them in at the first wash stage.

exercise 10

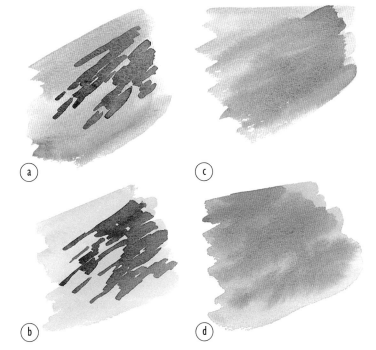

a

b

c

d

painting shadows

Cast shadows can be very sharp-edged and clear, or soft and diffused, depending on the distance and the light conditions. For hard shadows, work wet-on-dry over a base wash, or put in the shadows first and lay the wash on top. In either method the two colours will mix slightly and modify one another. In the first example (a) an ultramarine and Payne's grey mixture has been laid over pale burnt umber, and in the second (b), Payne's grey has been laid over sap green. For the more diffused shadows in the other examples (c and d), the same colour combinations have been worked wet-into-wet.

mixing greens

Green is among the most varied of colours in the spectrum; there are hundreds of different colours that can be loosely described as green, ranging from near-yellows to almost blue-greens. Practise mixing these colours, and you will soon be able to look at a tree and identify a suitable mixture for it.

warm and cool colours

Artists group greens – and most other colours – into two main categories: warm and cool. The cool greens are those that veer towards blue, and the warm ones have a stronger yellow bias. Of the two greens in your palette, one (viridian) is cool, and the other (sap green) is warm. You can mix both warm and cool green from blue and yellow, so do not be over-reliant on the ready-mixed greens; use them as a basis for mixtures rather than on their own.

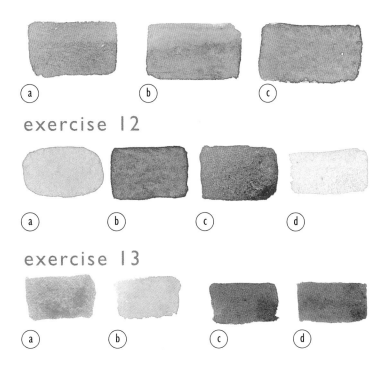

exercise 11

(a) (b) (c)

exercise 12

(a) (b) (c) (d)

exercise 13

(a) (b) (c) (d)

mixing warm greens

Ultramarine is the warmer of the two blues in your palette, and Indian yellow and yellow ochre are warmer than lemon yellow, so try mixtures of these. From left to right: (a) Indian yellow and ultramarine, (b) Indian yellow and Payne's grey, and (c) yellow ochre and phthalo blue. Both Payne's grey and phthalo blue are cool, but they are warmed by the yellows.

mixing cool greens

Next, try mixing the two coolest colours in your palette: lemon yellow and phthalo blue, which makes a very strong, acidy green (a). Then try mixing a cool yellow with a warm blue and vice versa, and varying the proportions, with more blue and less yellow. The other mixtures shown here are: (b) yellow ochre and phthalo blue, (c) yellow ochre and ultramarine, and (d) lemon yellow and ultramarine.

modifying ready-made greens

Sap green can sometimes be used 'neat', as it is quite close to some of the colours seen in summer foliage, but it often needs modifying by mixing with another colour, as does viridian. Try mixing blues, yellow and greys into your two greens. From left to right: (a) viridian and Indian yellow, (b) sap green and yellow ochre, (c) sap green and ultramarine, and (d) viridian and Payne's grey.

course 3

willow trees
in summer

I n this verdant summer landscape, the emphasis is on strong brushwork, so you will be working mainly wet-on-dry, with some wet-into-wet applications in the early stages.

simplification and balance

Jill Bays has given additional punch to this scene by simplifying the willow trees to make the most of the characteristic strong downward sweep of the foliage. She has also avoided the very dark blue-green shadows that obscure much of the foliage in the photograph, choosing instead to paint both trees and path in brilliant greens, with darker brushstrokes laid on top. An important compositional decision was to link the two trees by taking the shadow right across from one to the other.

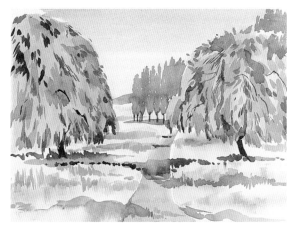

the finished painting

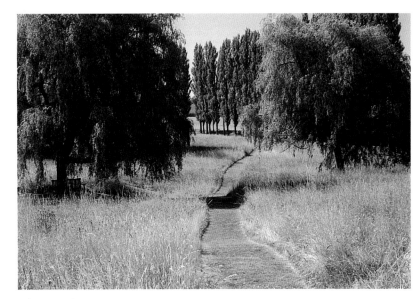

the view

YOU WILL NEED

Colours
ultramarine
phthalo blue
cadmium red
sap green
viridian
yellow ochre
burnt umber
Payne's grey

Brushes
large and medium
round
medium flat

**Paper and
other
equipment**
425gsm (200lb)
NOT surface paper,
unstretched or
300gsm (140lb)
NOT surface paper,
stretched
3B or 4B pencil

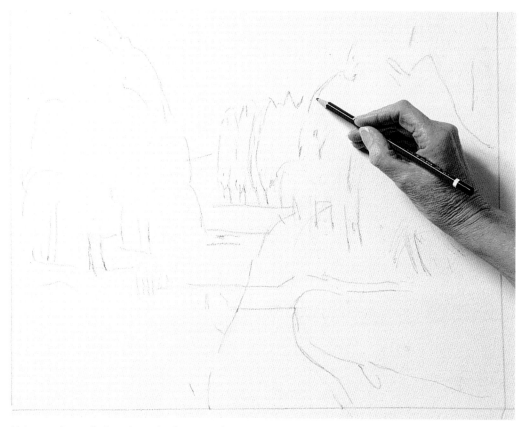

Using a soft pencil, place the main elements of
the composition. Keep the lines loose, but pay
special attention to the shapes of the trees, the
relative thickness and angle of the trunks and
the perspective of the path.

step 1

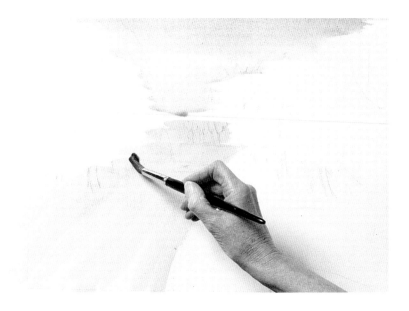

Working on dry paper, lay a light wash of ultramarine over the sky, stopping it at the edges of the trees so that the yellow-green laid on later will remain clean. Then lay a yellow ochre wash over the whole of the ground, leaving the path as white paper for the time being.

step 2

2 While the ochre wash is still wet, work an orange-brown mixture made from burnt umber, yellow ochre and cadmium red into it in a series of horizontal bands.

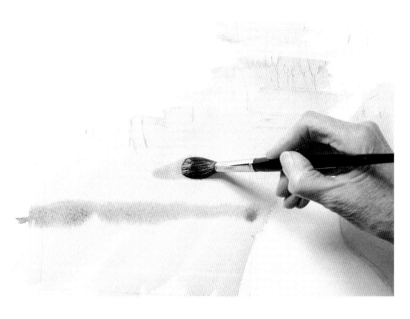

step 3

3 Leave the first washes to dry, and then
paint the distant fields with phthalo blue.
Use a mix of Payne's grey and yellow
ochre to paint the poplar trees, making
irregular upward strokes with the
large round brush.

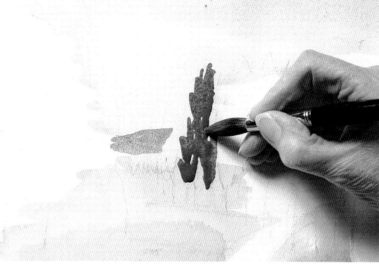

step 4

4 The first stage of blocking in the willow
trees is done wet-into-wet, so damp the
paper first with a sponge, and use the
large brush and a mixture of sap green
and yellow ochre to make downward
strokes describing the shapes. Take the
brush down over the dry paper at the
bottom so that it forms hard edges.
Paint the path in the same way, adding a
little viridian to the mixture.

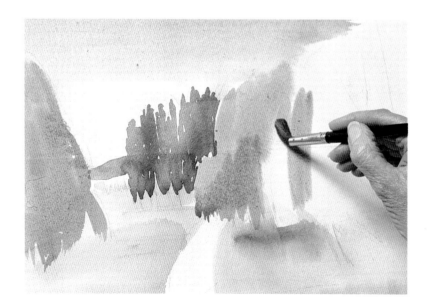

step 5

5 Build up the trees in stages, first using the large brush and a mid-green made from sap green and burnt umber to suggest the broad areas of foliage, and then adding darker detail. For this, use the tip of the smaller brush lightly to apply a stronger mix of the same two colours plus Payne's grey.

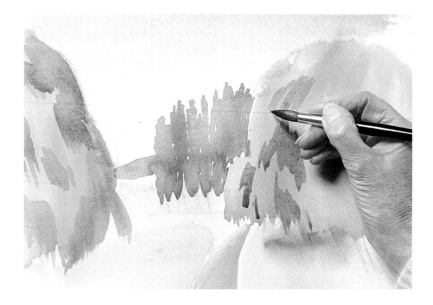

step 6

6 Continue to build up the foliage, this time with a mix of Payne's grey and burnt umber, varying the brushstrokes from small, fine lines to rounded blobs and squiggles, then paint the trunks and visible branches with the same colour.

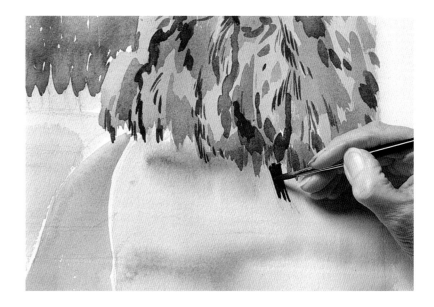

step 7

7 For the main shadow, return to the sap green and burnt umber mixture used for the trees, and make upward strokes and squiggling marks with the large brush to imitate the way the shadow is broken up by the grasses.

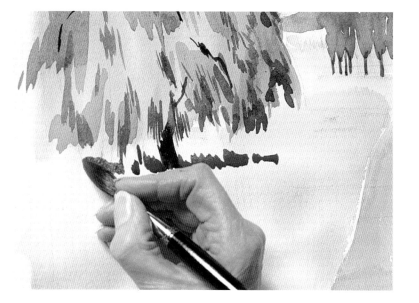

step 8

8 Using a more diluted version of the sap green and burnt umber shadow colour, lightly touch in the shadow beneath the poplars, holding the brush near the middle of the handle to give a loose line.

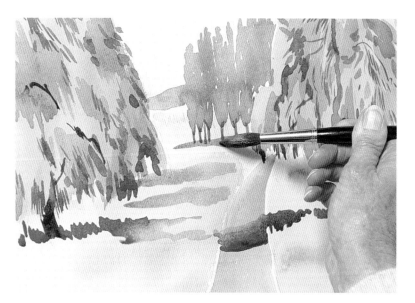

step 9

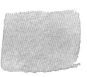

9 Place the other tree shadows, making sure the shadow on the path dips down in the centre. To give a broad impression of the grass texture, use the flat brush and a mixture of yellow ochre and sap green just slightly darker than the colour beneath. Pull the brush down the paper so that the hairs splay out slightly, creating tiny fine lines.

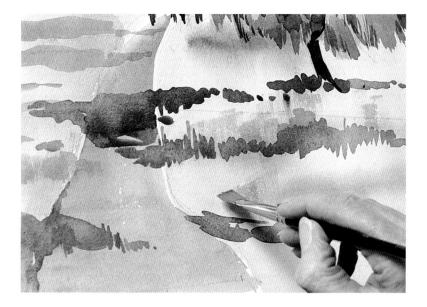

step 10

10 Let the earlier layer dry before working the finer texture wet-on-dry. Paint delicate upward strokes of yellow ochre, and then paint firmer strokes with the same orange-brown used in step 2 – a mix of burnt umber, cadmium red and yellow ochre.

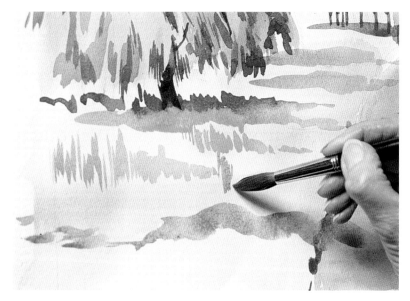

The quality of the brushwork is all-important in this painting. Not only has it been used very effectively to describe the shapes and textures, but it also forms an integral part of the composition, and imparts a feeling of movement and energy to the scene. Notice also how the colours have been chosen to give a sense of space, with the cool blue-green of the poplars receding and the warm orange-browns in the foreground coming forward to the front of the picture.

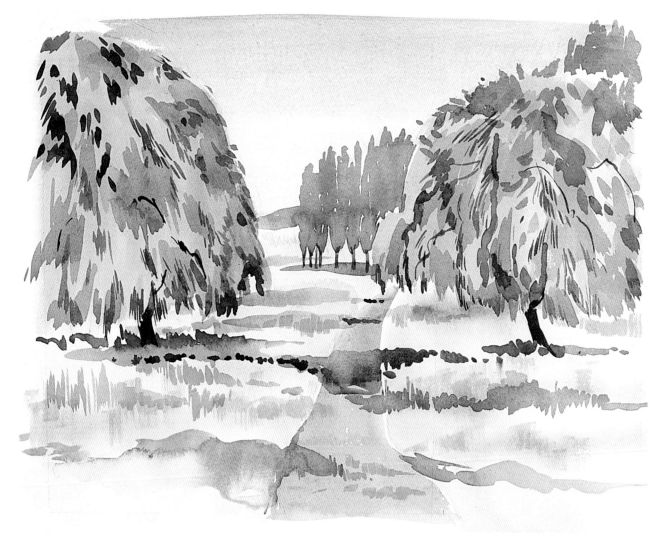

Willow Trees in Summer, Jill Bays

Buildings

The man-made world provides as many potential painting subjects as natural landscape, from humble dwellings to the grand architecture of cathedrals and castles. If you feel that complex structures are beyond your capabilities, try painting small details of buildings, perhaps making a feature of colour, texture or shadows. The artists featured on these pages have all found inspiration in buildings, but in very different ways.

Looking South on Michigan, David Becker

This painting also exploits the effects of light, but the treatment is much looser, as the artist was more interested in atmosphere than detail. Areas of the picture have been worked wet-into-wet, with care taken to reserve the crisp edges of the sunstruck walls. In places, notably at the top and right, it is the pencil drawing that defines the shapes.

The Ponte Vecchio, Florence, Gerald F. Brommer

The artist has given an individual slant to this much-painted view by exploiting the effects of light, with the sunlit buildings standing out sharply against the massed clouds behind. The buildings themselves are meticulously painted, with attention paid to both detail and texture, but light is the main theme.

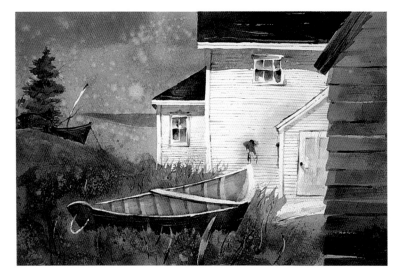

Near the Monhegan Light, Maine, Miles G. Batt

In this unusual near-monochromatic painting, with powerful tonal contrasts, the artist has used the curving shapes of the boats and the free forms of the grasses and tree as counterpoint to the starkly geometric pattern of the walls and roofs. To give the background additional interest, he has dropped water into the paint to create small blotches and star-like shapes.

Morning Shadows, Shelley Lazarus

To make paintings of buildings really exciting, you will often have to wait for the light to strike in a certain way, as this artist has done. The sun on the walls creates a lovely rose pink, and the angled shadows thrown by the open shutters provide a perfect compositional foil for the larger shapes.

Boathouse, Maine,
Leonard Mizerek

Shape and texture are the twin themes here, but the painting also imparts a strong sense of atmosphere. The composition is carefully contrived, with the boathouse placed centrally and just touching the frame at the top, and the anchor making a diagonal that is balanced by the opposing diagonal of the leaning post.

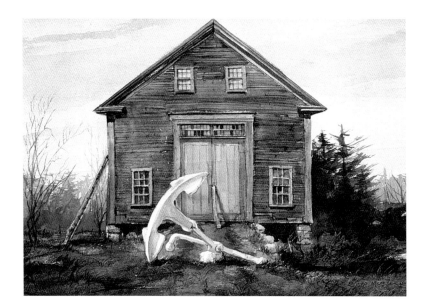

mixing neutral colours

A potential problem with paintings of buildings is that the muted colours are often hard to identify in terms of paint colours. This can result in over-mixing in an attempt to capture exact shades of grey and brown, and you may produce a muddy-looking painting. Try to stick to two, or at the most three colour mixtures and use just one colour wherever possible.

exercise 1

sap green and cadmium red

viridian and alizarin crimson

burnt umber and ultramarine

burnt umber and phthalo blue

Payne's grey and alizarin crimson

mixing two colours

Colours that are opposite one another on a colour wheel, such as red and green, are called complementary colours, and they are especially useful in mixtures because they cancel each other out to make a neutral colour. Red and green, for example, produce a range of browns that varies according to the proportion of each colour. Try these first, then try other two-colour mixtures, such as burnt umber and blue.

Payne's grey and raw umber

raw umber and alizarin crimson

exercise 2

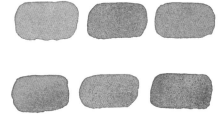

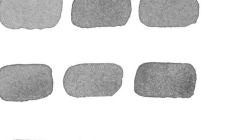

alizarin crimson, yellow ochre and ultramarine

cadmium red, Indian yellow and ultramarine

cadmium red, lemon yellow and phthalo blue

mixing three colours

You can achieve a range of lively neutrals by mixing the three primary colours: red, yellow and blue. You have two versions of red and blue in your palette, and three yellows, so try out different mixtures, varying the proportions.

rendering
texture

Although masonry is not a highly colourful subject, buildings have other qualities that draw artists to them. One is the large, strong shapes, often contrasted with smaller and more intricate architectural details, and another is texture. These exercises show you different ways of rendering texture.

tricks with paint

Because watercolour is a fluid medium that naturally dries flat, you will have to use some special techniques to create textures such as those of old stone, weathered wood and brickwork. One method often used for buildings is drybrushing, in which you drag paint over a base wash so that the original colour is only partially covered. Another is spattering – flicking small droplets of paint over flat or semi-flat colour.

exercise 3

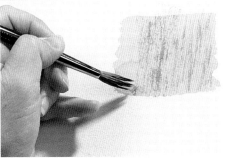

drybrushing

To render brickwork, begin by laying a flat wash of light cadmium red or a red and burnt umber mixture. Let this dry while you mix up a slightly darker colour made from alizarin crimson and ultramarine. You need the minimum of paint on the brush, so after dipping it into the mixture, remove the surplus with your thumb and forefinger, fanning the hairs out slightly and then lightly dragging the brush over the base colour.

exercise 4

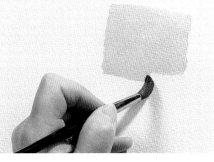

spattering

This method is less precise and controllable than drybrushing, but is useful for a more generalised suggestion of texture. Usually, you will want to restrict the spatter to one area of a picture, so mask off the rest with masking tape or pieces of cut paper. Lay a base wash, leave it to dry and make up a slightly darker colour for the spatter. Dip the brush in, flick it with your finger to release droplets of paint, and then shake it downwards. Spatter another layer in the same way, using a different colour.

resist
methods

Wax resist is another excellent way of suggesting texture. This technique involves partially blocking the paint by laying on wax before painting. Wax is oily, and water and oil do not mix, so the paint will settle only in the non-waxed areas. If the wax is used lightly, it will cover only the top grain of the paper, so that the subsequent layers of paint will have an attractive speckled appearance.

what to use

You can work the wax underlayer with an ordinary white household candle, or with a wax crayon or white oil pastel. Since you will be working white on white you will not see what you are doing very clearly, but you can to some extent judge by feel how much you are putting on. To check whether you have covered the area, hold the paper up horizontally to the light and you will see the sheen of the wax.

You need not restrict yourself to white wax; you can also use coloured wax crayons or oil pastel beneath the paint. Some artists build up whole paintings in layers in this way, starting with wax crayon, and following this with more paint and then further applications of crayon. This is an exciting technique that appeals to those who enjoy more experimental approaches.

exercise 5

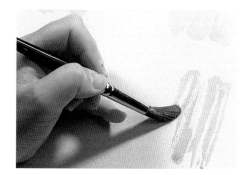

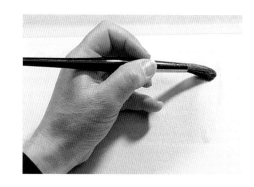

candle-wax resist

A candle may seem a clumsy implement, but you can actually be quite precise with it, using the edge to make crisp lines, or holding it vertically to rub the flat end over the paper. Draw a rough guideline, then apply the candle lightly before laying a wash on top. Next, use the candle more heavily, pushing it well into the grain of the paper so that it blocks the paint more thoroughly.

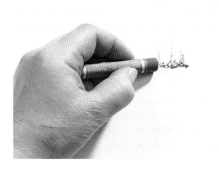

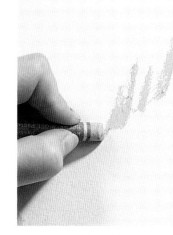

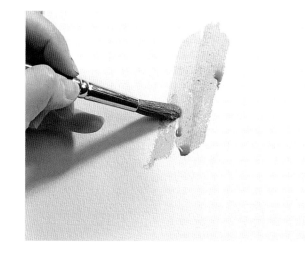

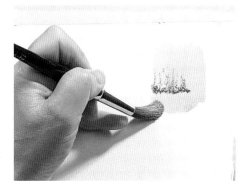

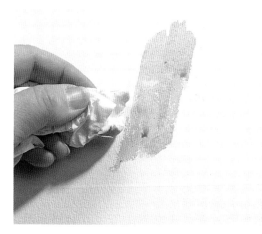

Next, try working with colours more closely related in tone. Lay on blocks of colour with a blue-green crayon, followed by a fairly strong wash of ultramarine and yellow ochre. If small pools of paint collect between the crayon strokes, you can either mop them up with a tissue or leave them to add to the texture effect.

coloured wax crayons

There are as many variations of this method as there are colours, so you can try out a variety of different effects, tailoring them to your chosen subject. For stonework, you might use light grey under darker grey or vice versa, and for bricks a combination of red-browns. Start with a dark colour such as a rich brown, holding it lightly to achieve a feathery effect, then lay a wash of yellow ochre on top.

straight lines
and edges

Paintings of buildings are often spoiled by leaning vertical lines and wobbly edges. There is no rule against using a ruler when you are making the drawing; the mechanical-looking lines will be quickly obscured by paint, or you can rub them out after laying the first washes. To maintain edges when you are painting, there are various masking devices you can employ.

masking out

If you want to lay a loose, free wash around an edge, such as a rooftop or the side of a building, you may find masking methods helpful, as there is always a danger of paint slopping over. You can use masking fluid (see page 44) for small straight-edged details, but for large areas masking tape is a better choice. Do not leave it on too long or it may mark the paper and will become difficult to remove, and resist the temptation to take it off before the paint is fully dry.

exercise 7

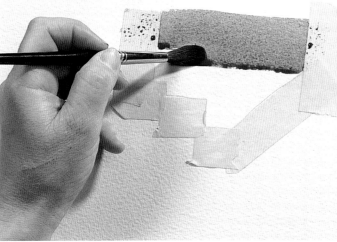

masking tape

The best tape to use is low-tack, but if you can only obtain standard high-tack tape, remove some of the strength of the adhesion by lightly sticking it onto your arm or the back of your hand. If the tape is too sticky it may scuff the paper when removed. Make your preliminary drawing and stick

the tape down where needed. Here, a rooftop and chimney on one side and the straight edge of a wall are masked before the sky wash is laid on. Let the wash dry and then gently lift the tape.

masking fluid

Small details such as this window frame can be protected with masking fluid. You will not achieve such a crisp line as you can with tape, but this is unlikely to matter; indeed, it may improve the painting to have freer lines in places. Paint on the fluid, then wash your brush immediately. When the fluid is dry, lay the wash, and leave this to dry before removing the masking, either with your finger or with an eraser.

CHECKING PROPORTION AND PERSPECTIVE

You do not need an extensive knowledge of perspective to draw buildings accurately as long as you spend a little time checking them first. The most basic rule is that receding horizontal lines – that is, those seen at an angle – become diagonals, and gradually begin to converge, meeting at a point in space known as the vanishing point. Thus the diagonal lines formed by the top and bottom of a roof or wall will appear to slope inwards, making a wedge shape. You can check these important angles by holding up a pencil or ruler, adjusting it to coincide with the angle, and then very carefully taking it down to the paper to make your pencil marks.

Proportion is just as important as perspective, so use your pencil again to check relative sizes. For example, to decide whether the space between two windows is greater or lesser than the windows themselves, measure each in turn by holding up the pencil and sliding your thumb along it.

1 THE VANISHING POINT (VP) is always on your own eye level, so the angles will change according to where you are viewing from. There will be a significant difference even if you change from a standing to a sitting position. Here, the eye level is the top of the door.

2 NOW THE EYE LEVEL is much higher, just below the eaves of the roof, as it would be if you were viewing from an incline. The angles at the bottom are much sharper, and those at the top slope more gently to the vanishing point.

It is vital to hold the pencil out firmly at arm's length, because if you bend your arm even slightly the measurements will be dramatically altered.

82

course 4

Tunisian scene
masking and texturing for buildings

Y ou will be using both the masking methods and the texturing techniques you practised in the Saturday exercises for this painting. The latter, however, serve only to add a touch of additional interest; special techniques should never be allowed to predominate and take over from the more important elements of colour and composition.

editing for composition

Whenever you work from a photograph, remember that you do not have to put in every feature. Sometimes you can make a stronger composition by leaving out small details, and by using only part of the image, as Annie Penney has done here. She cropped the photograph with masking tape to get rid of most of the sky and the odd shape at the top left. She also used artistic licence for the colours, heightening the red of the central door and bringing in greens and yellow-greens to give a touch of complementary contrast.

Top part of photograph masked out

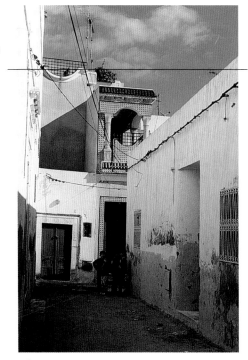

the view

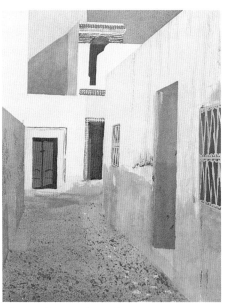

the finished painting

YOU WILL NEED

Colours
ultramarine
viridian
yellow ochre
lemon yellow
alizarin crimson
cadmium red
burnt umber
Payne's grey

Brushes
Nos 12, 10 and 1 round
brushes, or equivalent —
that is, large, medium
and small

**Paper and other
equipment**
425gsm (200lb) NOT
surface paper,
unstretched or 300gsm
(140lb) NOT surface
paper, stretched
masking fluid
white wax candle
yellow ochre and brown
wax crayons or oil pastels
masking tape
3B or 4B pencil

In landscape you can often restrict the drawing to a few loose
lines, but for architectural subjects you need to establish the
proportions and perspective and to be sure that the
perpendicular lines are true. You can use a ruler for these, or
hold your pencil against the paper, as Annie is doing, to check
the line of the wall against the angle of the roof.

step 1

Consider areas of resist texture first. Texture the wall on the right by scribbling lightly over it with the candle, then make small marks with the brown crayon or oil pastel for the discoloured patch beside the door. Make the marks smaller and lighter as they recede, and make sure that they follow the perspective lines.

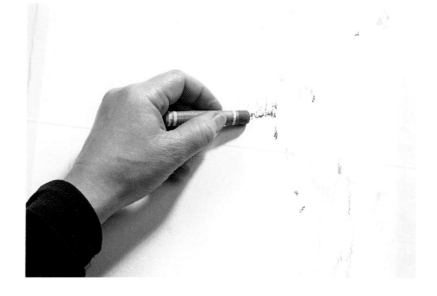

step 2

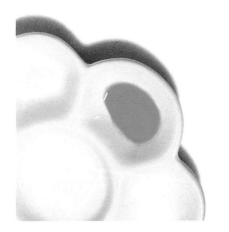

2 Now use tape to mask off the areas that are to remain as white paper for the time being: the sky and the central wall. Using the large brush, lay a dilute wash of yellow ochre and cadmium red over the right-hand wall and the path.

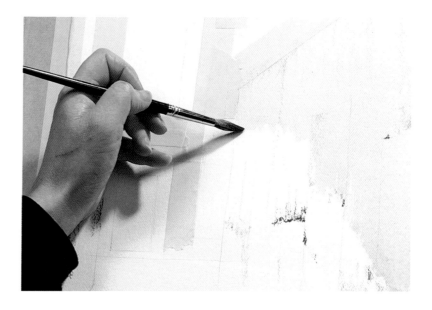

step 3

3 Leave the first wash to dry, or dry it
with a hairdryer, then use a slightly
stronger version of the colour to paint
in the door and windows. Use a little of
this mixture also to create darker tones
and texture on the wall, blotting with a
tissue to lift some of the colour.

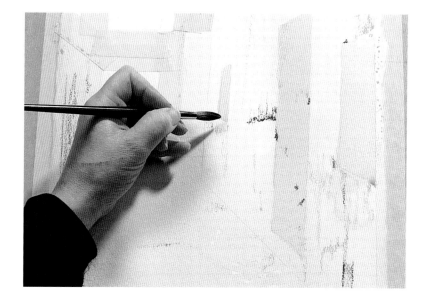

step 4

4 With the masking tape still in place, and
continuing to use the large brush, lay a
wash of cadmium red and yellow ochre
on the background wall and then flood
in a mix of ultramarine and lemon
yellow to create shadow.

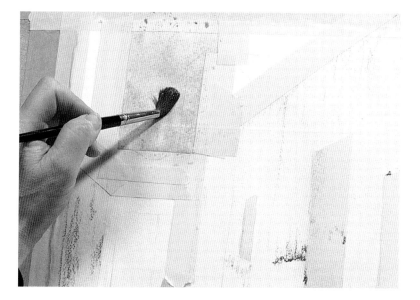

step 5

5 Now the foreground needs to be
darkened to balance the background
wall. To provide a base colour for the
path and create the shadow along
the bottom of the wall, lay a wash of
ultramarine and yellow ochre, working
some of this same colour into the
background wall (see step 4). Be
very careful with the top of the
shadow, as the perspective angle
must be consistent with those of
the path and the top of the wall.

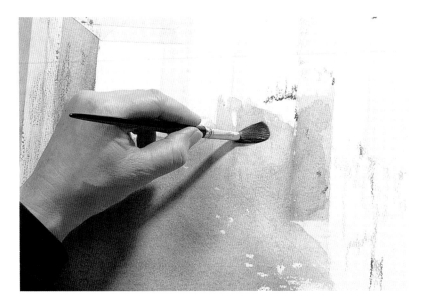

step 6

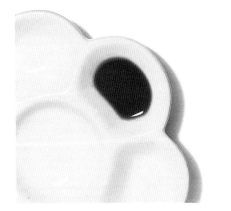

6 The path is now to be spattered to
create texture, so let the wash dry and
mask off the area. Mix up alizarin
crimson and Payne's grey, with a higher
proportion of crimson, and spatter with
the medium brush, concentrating the
drops towards the front of the picture.
Spatter another layer on top to add
depth, using the same two colours but
this time with more grey.

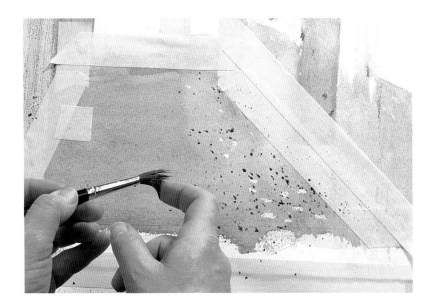

step 7

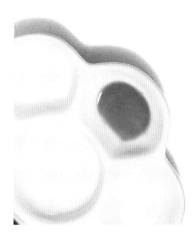

7 Use the same mixture to work into the shadow on the right-hand wall and, when dry, build up the colour and texture by drybrushing with the large brush and a mixture of yellow ochre and cadmium red.

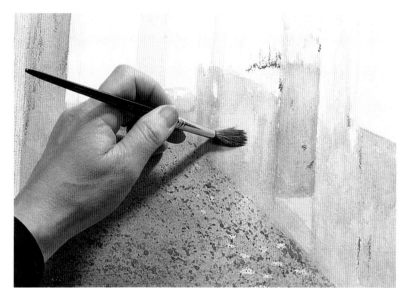

step 8

8 Remove all the masking tape and begin to work on the most vivid areas of colour: the two central doors and the sky. Use strong mixtures for all these – cadmium red and yellow ochre for the tall thin door (to which you then add alizarin crimson for the central door) and an ultramarine and viridian mix for the small area of sky.

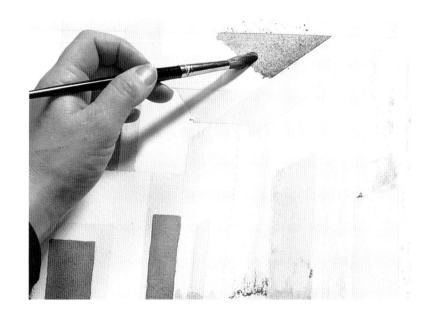

step 9

9 To paint the detail onto the central door, use a small brush and a strong mix of Payne's grey and alizarin crimson. With the same colour mix, first lay a wash over the other door, leaving a small patch of the lighter colour, and then paint in the shadow under the archway.

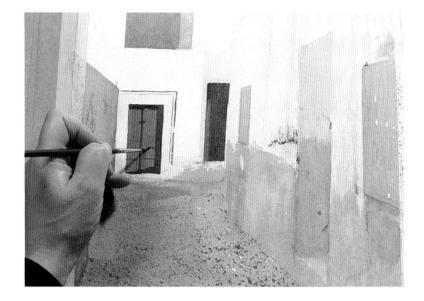

step 10

10 Finally, paint the zigzag bars on the two right-hand windows with masking fluid and the small brush. Wash over them with yellow ochre followed by ultramarine, and reinforce the side of the doorway with the same colours. Use the fluid again for the blue and white pattern, washing over it with strong ultramarine and a band of yellow ochre.

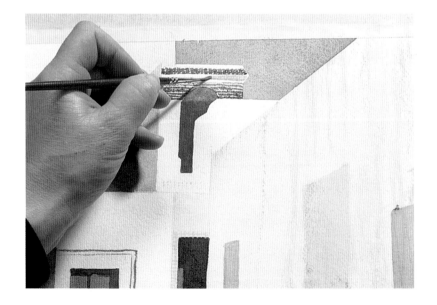

The painting derives its strength from its apparent simplicity, with the composition based on the interaction of geometric shapes. This gives it a strong abstract quality – that is, the arrangement of shapes and colours is pleasing in itself, regardless of what they represent. The spattered paint on the path gives a touch of texture that contrasts with the stark whiteness of the end walls, and creates interest in an area that could otherwise have been dull.

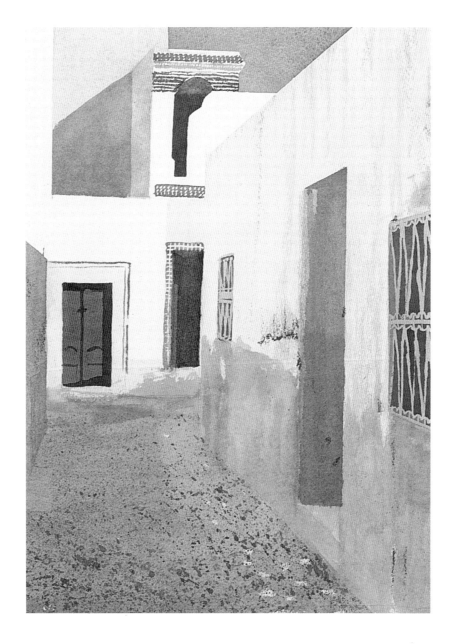

Tunisian Scene,
Annie Penney

Flowers

Flowers are among the most popular of all painting subjects, and you only need to look at the array of glowing colours in a summer garden to see why. But take care over composition as well as colour, and decide whether you are interested in detail or in creating a broad impression. The paintings shown here will give you some ideas about different approaches.

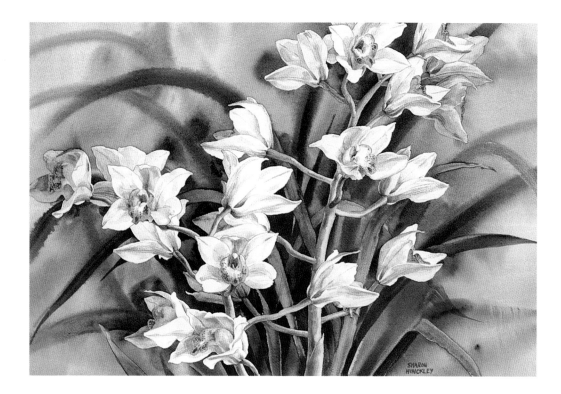

Cybidium, Sharon Hinckley

The delicate blooms of this orchid-family plant seem to demand a detailed treatment, and the artist has made the most of the curving petals and the intriguingly shaped centres. Notice how she has let some of the flowers go out of the frame at the top of the picture. This not only strengthens the composition, but also conveys a sense of growth and movement, as though the flowers are not confined in the picture, but are continuing their life outside it.

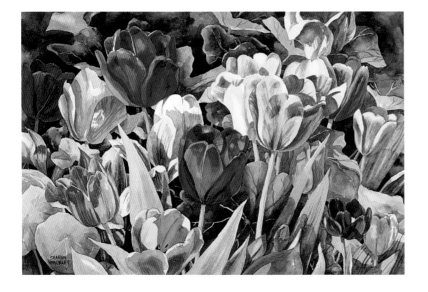

Tulips in the Garden, Sharon Hinckley

Flowers don't have to be cut and placed in vases; they can also be painted outdoors in their natural habitat. The artist has made an excitingly busy composition of this bed of tulips, with the spiky leaves contrasting with the heavy, rounded curves of the flower heads.

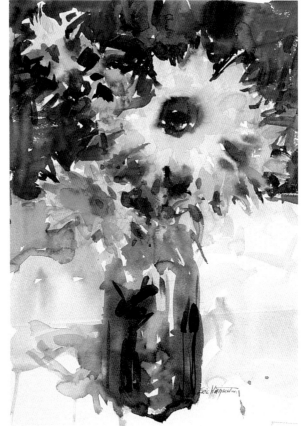

Spring Bouquet, Tom Francesconi

One of the compositional problems inherent in flower arrangements is that you may have a lot of blank space at the sides of the vase. This can be solved by cropping the vase, as the artist has done here, or by omitting it altogether, as in Sharon Hinckley's painting of the white flowers. Here, the top of the vase acts as an anchor for the outward spread of the flowers, which are painted in a loose, free manner that gives the painting life and energy.

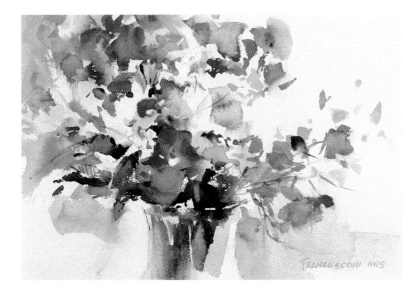

Sunflowers, Eric Wiegardt

This artist has taken the approach of treating the flowers broadly, and working wet-into-wet in places – you can see how the paint has run outward from the centre of the large flower. He has suggested the petals by weaving brushstrokes of dark background colour into and around them, and has unified the composition by repeating the purplish brown of the flower centre in both the background and on the vase.

masking
out

Painting white or light-coloured flowers against a darker background can be tricky in watercolour, but masking fluid makes it easy. Simply paint on the fluid to reserve the white areas and then remove it when the other colours are in place.

masking shapes

It is easy enough to reserve simple geometric shapes as highlights by painting around them, but less easy for more complex areas such as flower petals. The beauty of masking fluid is that it enables you to paint the flower itself, just as you would if you were using an opaque medium such as oil or acrylic paint. When the fluid is removed you will have flat shapes, which you can model by adding shadows and details such as the flower centres, stamens and any petal markings.

exercise 1

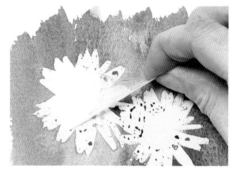

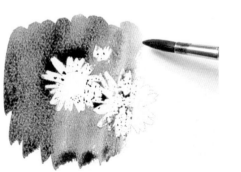

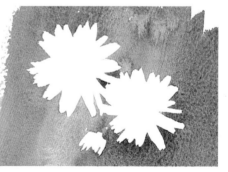

masking white flowers

Make a drawing before putting on the masking fluid, taking the brush outwards from the centre of the flowers to create a slightly ragged edge. Wash the brush immediately and leave the fluid to dry, or dry with a hairdryer. Lay a dark background wash over the whole area – here, a mix of sap green, ultramarine and burnt umber is used – and leave this to dry before gently lifting off the fluid. If you start by lifting it at the top it should come off in a single sheet.

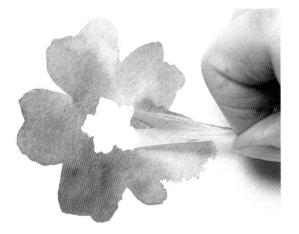

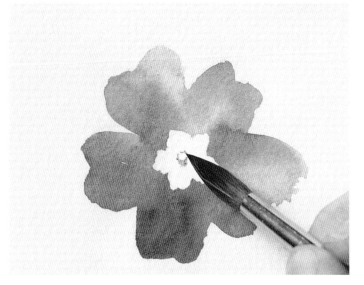

masking over colour

You can also lay masking fluid over an existing colour to reserve pale rather than pure white shapes. Lay a wash of dilute Indian yellow, leave it to dry and mask out the centre. When dry, paint the flower with alizarin crimson. Remove the masking, damp the centre and dab a touch of sap green into it, pulling out the colour to make small lines.

94

course 5

wet-into-wet

Flower painters make extensive use of wet-into-wet methods, not only to paint backgrounds, where it can give an attractive loose effect suggesting undefined space, but also for certain areas of the flowers themselves, such as the centres.

controlling the effects

The wet-into-wet technique can be unpredictable over large areas, but for smaller ones it can be quite precisely controlled. You can do this by damping just one petal or flower centre, or by laying a base colour and dropping further colours into it with the tip of the brush. The paint will only spread where the paper is damp, stopping as soon as it meets dry paper.

exercise 3

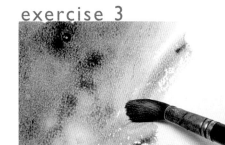

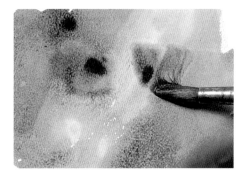

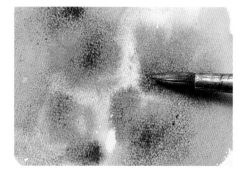

broad effects

Loose wet-into-wet effects are ideal for backgrounds, where they create the impression of undefined space and contrast with the crisper treatment of the flowers. They are also useful for the more distant areas in outdoor flower paintings. To suggest a field of poppies, damp the paper and use a large brush to lay on sweeping strokes of an ultramarine and Indian yellow mix, dropping in blobs of alizarin crimson. Notice how the crimson spreads outwards, forming random edges as it dries.

exercise 4

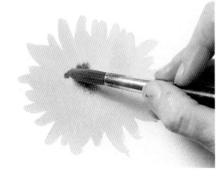

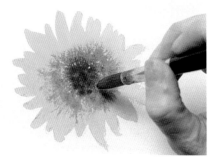

flower centres

Painting the centres of flowers wet-into-wet creates a soft, impressionistic effect that could be ideal for a group of massed flowers, where colour and shape are more important than precise detail. For this sunflower lay a wash of Indian yellow and let it dry a little so that the paper is just damp. Using the tip of the brush, drop in burnt umber and let it spread out before adding darker colour in the centre.

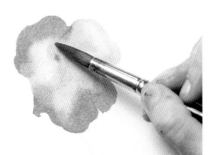

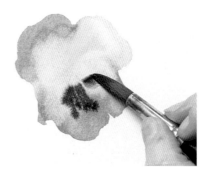

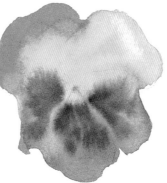

For the polyanthus, which has separate areas of colour, you will need to begin with a variegated wash. Start with dilute alizarin crimson around the edges and work in Indian yellow, pushing the red away with your brush. For the centre, make downward lines with the tip of the brush, using a purple mixed from alizarin crimson and ultramarine.

building up

forms and edges

To make a flower shape stand out clearly you can use a darker colour to paint what is known as the 'negative space' around it, but this will result in hard edges where light meets dark. You may have to soften at least some of these edges because they will destroy the impression of form. Petals are not flat shapes; they usually curve away from the light, with the brightest areas in the middle. Edges can be softened with a brush dipped into water, or you can add shadows to express the curves, painting wet-into-wet or wet-on-dry.

T he first step in flower painting is getting the main outlines right, but you will often have to redefine and emphasize some of the shapes, soften edges in places, and add shadows to explain the forms and characteristics of the flowers more clearly.

exercise 5

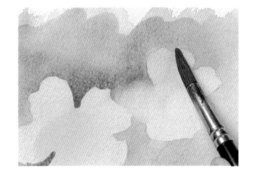

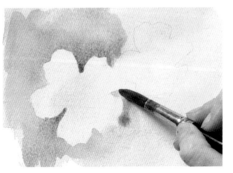

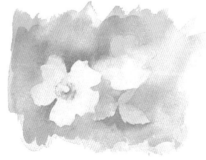

defining the shapes

To paint these delicate dog roses, start with loose, broad strokes of dilute alizarin crimson and then work in Indian yellow. Leave the washes to dry, and then paint the negative space around the flowers and leaves with a greenish-brown mixture, adding darker colour around the petals to crisp up the edges and suggest dappled light. With the paint still damp, soften some of the edges with a damp brush, then lay light shadows on the back petals. Finally, paint the centre of the main flower by dotting in the background green wet-into-wet (if the yellow centre has dried, redamp it).

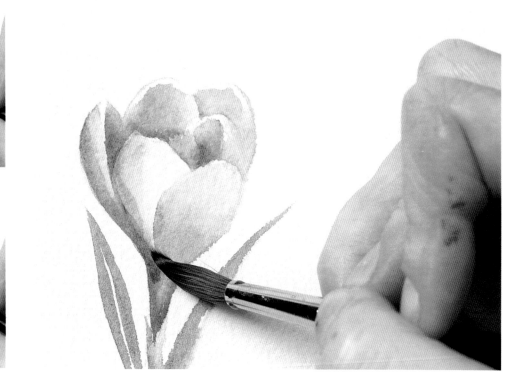

building up wet-on-dry

A crocus has a strong, sculptural shape, with the curving forms of the petals producing considerable tonal variation and clear, crisp edges. Begin with very dilute purple – either permanent magenta (see page 98) or a mix of crimson and ultramarine – then add darker colour, leaving lines of white to prevent the colours running together. Continue in the same way, concentrating most of the colour in the shadowed centre and beneath the flower. Add the leaves with a mix of ultramarine and Indian yellow.

shadow colours

limitations of mixtures

You may sometimes find that you cannot match the brilliant colours of flowers by mixing, so you may in time want to invest in one or two extra colours. Two especially useful ones are permanent magenta and permanent rose. Although you can achieve a range of purples by mixing crimson and ultramarine, these mixtures are not as vivid as the ready-made magenta, and permanent rose is purer and brighter than alizarin crimson. However, your basic palette colours are fine for many flower subjects, so try out the mixes shown here first.

Whenever you mix colours you 'devalue' them to some extent – that is, they become less clear and bright – so try to stick to mixtures of no more than two colours for the shadows, varying the proportions as needed.

exercise 7

yellow and orange flowers

Indian yellow is perfect for daffodils, so start with this, adding a stronger mix of the same colour for the trumpet. For the shadows, mix in a little raw umber to give a slight greenish tinge to the yellow.

For the chrysanthemum, lay a base wash of Indian yellow and cadmium red, with more yellow at the top where the flower catches the light, then paint the shadows with a burnt umber and alizarin crimson mixture.

exercise 8

pink and red flowers

The red of a tulip may require no mixing. Start with cadmium red, blotting lightly with a tissue at the bottom, where it catches the light. Add shadows with a mix of alizarin crimson and ultramarine, with more blue at the bottom, where the form curves away from the light.

For this rose, lay a variegated wash of lemon yellow grading to alizarin crimson, then put in the shadows with a dilute mix of crimson and ultramarine.

exercise 9

blue and white flowers

Start with ultramarine, varying the tones by letting the paint pool a little in places, and add a little alizarin crimson for the right-hand petals. For the shadows, use a stronger mix of the blue and crimson.

In the case of white flowers, it is best to paint the background before adding the shadows. Paint ultramarine around the flower at the top, and work in some lemon yellow at the bottom. Then paint the shadow with a weak mix of ultramarine and alizarin crimson, varying the proportions and using the strongest colour between the layers of petals at the bottom.

FLOWER SHAPES

Most flower shapes can be simplified, at least for the purposes of a preliminary drawing, where it is more important to identify the main shape than to engage with detail. Many flower shapes are based on a circle, or variations of a cup or bowl, so look for the way perspective affects these shapes, producing ellipses when a circular shape is seen at an angle. Look also for the relationship of flower to stem, which is often misunderstood. The stem grows directly up into the flower centre, so draw in the whole line of the stem even if you cannot see it because it is hidden by petals.

This is a star shape, with the five petals growing out from the central star. These also fit roughly within a circle.

This cup shape bends over slightly, so that the top ellipse is slanting.

Flowers of the daisy family are based on circles, so mark in the circle or ellipse before drawing the petals radiating out from the centre.

Anemones are bowl-shaped, a more open version of the cup, but seen from directly in front, the flower appears as a circle.

The relationship of stem to flower can be clearly seen in this bell shape, an upside-down version of the cup.

The lupin is basically a cone shape, but with slightly curving sides and often a gentle bend towards the pointed tip.

Daffodils and narcissi are combinations of two shapes, with the flaring cone shape fitting into a circular arrangement of petals.

course 5

winter
bouquet

planning a composition with
vibrant colours

Y ou will be painting both wet-into-wet and wet-on-dry for this colourful flower piece, reserving the white flowers by masking. One 'special' colour, permanent magenta, is suggested, but if you do not have this, use alizarin crimson.

mixed flower groups

When choosing flowers for a mixed group, avoid too many different colours and shapes, or the painting may look muddled and incoherent. Decide on one dominant colour, or a range of harmonising colours. Here, the brilliant magenta is the key colour, echoed by paler mauves, with the pure white freesias in the centre providing tonal contrast and a focal point.

When you have set up the group, consider how much detail you will put in and how to treat the background. Ann Blockley wisely left the background almost white, with just a hint of colour, which works well for these vivid, but deep-toned, flowers. She also omitted the vase because she wanted to exploit the outward sweep of the flowers by working to a horizontal format.

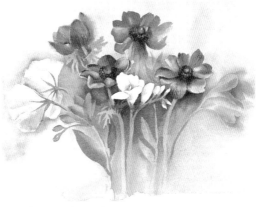

the finished painting

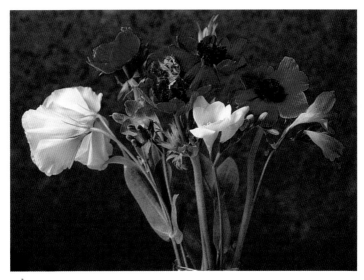

the set-up

YOU WILL NEED

Colours
ultramarine
alizarin crimson
lemon yellow
burnt umber
permanent magenta
sap green

Brushes
Large and medium
round

Paper and other equipment
425gsm (200lb) NOT
surface paper,
unstretched or 300gsm
(140lb) NOT surface
paper, stretched
3B or 4B pencil
masking fluid
cotton wool bud

Make a thorough drawing, outlining the shape of each flower head, and paying special attention to the lines of the stems. Draw in the foreground leaves also, as these are to be reserved as pale shapes against darker greens. When you are satisfied with the drawing, paint masking fluid over the freesias and the anemones to right and left.

step 1

Working on dry paper, lay a very dilute variegated wash of sap green and ultramarine, grading to a pale mauve mix of ultramarine and alizarin crimson over the whole area using the large brush. On the left-hand flower leave lines of white following the forms of the petals.

step 2

2 With the first washes still wet, take a darker green mixed from ultramarine and burnt umber around the top of the masked anemones and around the stems beneath the freesias.

step 3

3 Now begin to paint all the unmasked flowers wet-into-wet, starting with the freesias at the outer edges of the group, and using a mix of permanent magenta and ultramarine. For the top anemone use an alizarin crimson and ultramarine mixture, grading the wash from light to dark and adding more blue for the back petals. Paint the leaves wet-into-wet with a smaller brush and dark green previously mixed for the background.

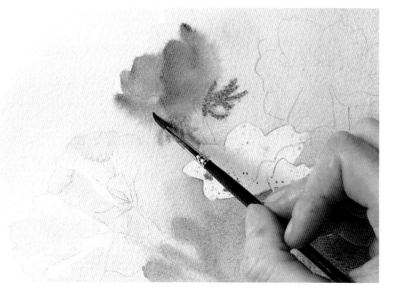

step 4

4 The right-hand top anemone is in sharp focus, requiring crisp edges, so let the paper dry and then paint it with the crimson and ultramarine mixture, lifting out highlights with a cotton bud. Add the centre immediately wet-into-wet, by dropping in a very strong mix of the same two colours.

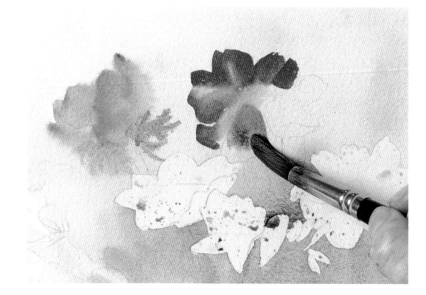

104

step 5

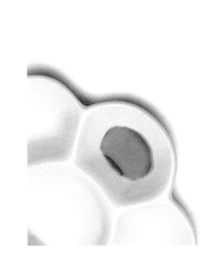

5 Take the dark green mixture used for steps 2 and 3 around the edges of the lisianthus to define the shape, using a damp brush to soften the edge where the darker colour meets the pale wash. Paint around the leaves and stems in the same way, to reserve them as pale shapes.

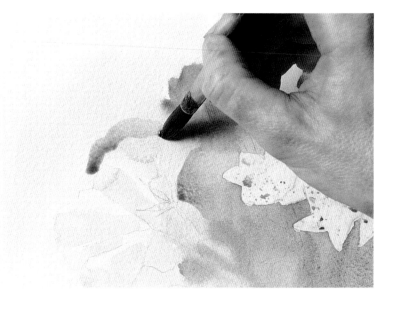

step 6

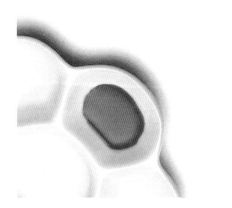

6 Build up the detail on the anemones with strong alizarin crimson. Use this colour for the front petals of the left-hand flower, leaving little lines of the lighter colour at the edges. Suggest the striations on the petals by lightly pulling the paint out from the centre with the tip of the brush.

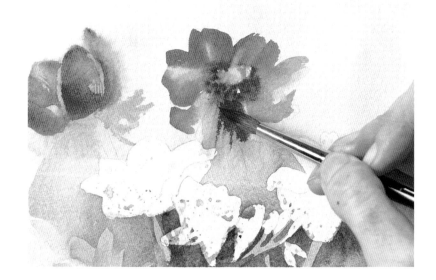

step 7

7 Remove the masking, making sure that the surrounding colours are fully dry. Mark in the centres of the two front anemones with pencil and paint them in varying tones of permanent magenta. Lay on a very strong, barely diluted wash, then rinse the brush and push the colour around to create soft gradations.

step 8

8 Add light touches of detail to the white freesias with a dilute lemon yellow and ultramarine mixture, and touch in the dark shadow at the centre with darker green, painting carefully around the stamen. To give more emphasis to the delicate flowers and buds, paint around them with a strong mix of the background green.

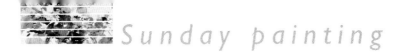 Sunday painting

step 9

9 Add further detail to the anemone with alizarin crimson, using the drybrush technique to suggest the tissue-papery texture, with the hairs of the brush splayed out slightly.

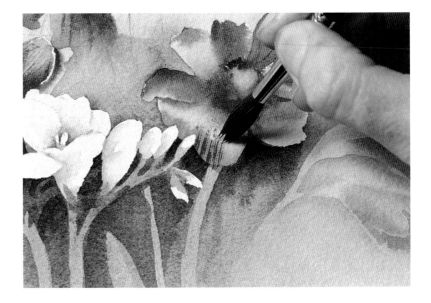

step 10

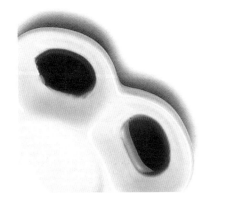

10 Go all over the painting, adding detail and strengthening colours where necessary. Then paint the stamen of the right-hand front anemone, dotting in a dark ultramarine and crimson mixture with the tip of the brush.

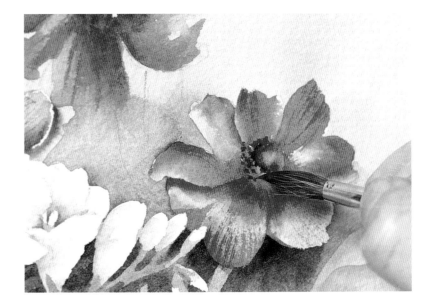

The painting looks simple, but its apparent simplicity is the result of a strong composition and careful planning during the painting. The focal point is the central white flower set against the triangular arrangement of the three anemones, and this is the area that has been treated in most detail, with the softer wet-into-wet effects kept to the background and edges. The artist has not attempted to engage in detail with the leaves and stems; these are simply reserved as pale shapes that give an element of pattern without stealing attention from the flowers.

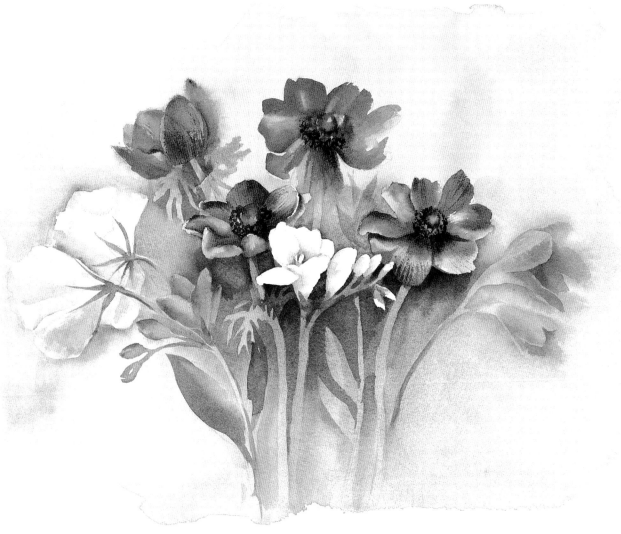

Winter Bouquet, Ann Blockley

Still Life

Pear and Grapes, Jeffrey Watkins

Here, the artist has made 'less say more' by restricting the elements in the painting but arranging them in such a way as to create an impact. His technique gives the picture additional interest: notice how the grapes have been painted with the background still wet so that the colours have run a little, in contrast to the paper, which has been built up with layers of colour wet-on-dry.

Some artists turn to still life subjects only when the weather is unsuitable for outdoor painting, but others find it a more rewarding genre than any other. Unlike a landscape subject, still life allows you complete freedom of choice, and apart from this, it gives you an opportunity to practise paint handling and to try out different ways of composing the picture.

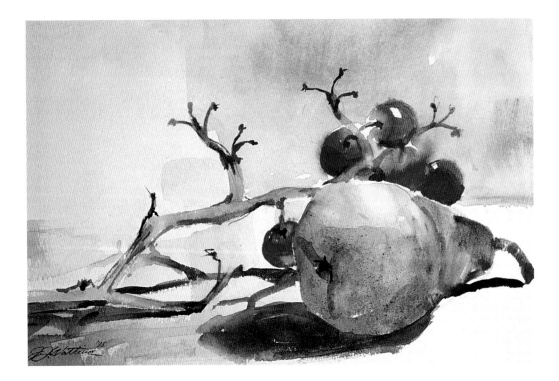

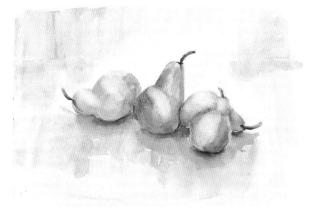

Pears, Rea Nagel

This is also a simple subject, beautifully handled and completely satisfying. The colours are pale and delicate, with no tone darker than the middle of the range, but there is nothing wishy-washy about the picture, indeed it seems to glow with light. The artist has not attempted much detail on the pears, but has built up the forms firmly, using cooler and slightly darker colours for the shadowed areas.

Breakfast for Two,
Adele Earnshaw

The majority of still lifes are painted indoors, simply because it is so often a poor-weather activity, but they need not be, and here, a table in the sun has provided an attractive setting. But this is not just a collection of objects randomly left over from a meal; the group has been arranged with great care, and painted with obvious enjoyment of detail, pattern and texture. You can almost feel the surface of the central metal teapot and the fineness of the china cup and saucer.

Gathering for Gardeners, Ruth Wynn

This unusual group has also been painted outside, with the light coming from behind and slightly to the left, throwing long, slanting shadows. These shadows are important to both the composition and the colour scheme, which is a simple but highly effective one based on the repetition of blue-grey and orange-brown throughout the picture.

painting form

blending methods

A watercolour wash, whether one laid on pristine white paper or one laid over another colour, naturally dries with hard edges. When you are rendering form and volume you do not always want these edges, but it is very easy simply to soften them with a damp brush or cotton wool bud. Also, if you work carefully and methodically, you can avoid edges forming, either by using rather dry paint and putting on a series of small brushstrokes, much like shading in a drawing, or by damping the paper just enough for the colours to merge into one another.

Creating the soft gradations of tone and colour that express form is less easy with watercolour than with a medium such as pastel, where colours can be rubbed into one another. But it can be done – it is just a matter of learning to control the paint.

exercise 1

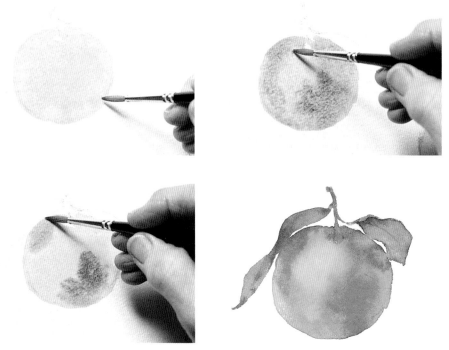

blending on damp paper

Draw the outline of an orange, then damp the paper and lay a flat wash of Indian yellow. Let the wash dry a little, so that it is just damp rather than wet, and drop in touches of cadmium red. Next, add a little ultramarine to the red for the shadows around the edges, and if the colours begin to flow into the highlight area blot very lightly with a tissue. Finally, paint the leaf with sap green and viridian, letting a little of the green run into the orange to suggest a shadow.

exercise 2

blending
wet-on-dry

Draw the outline
and then lay an all-
over wash of lemon
yellow, blotting out
a little of the paint
in the highlight area.
Let the wash dry
and mix up some
well-diluted Payne's
grey, then take up
just a little colour
on the tip of the
brush and drag it
lightly over the
paper so that little
patches of the
yellow remain
uncovered. Add
some stronger grey
at the bottom, and
for the shadow
beneath the lemon
paint a soft line of
warm orange-
brown. Finally, add
a touch of a sap
green and burnt
umber mix at
the bottom.

varying the textures

rough and smooth

The texture of an object does not directly affect its colour, but it does affect the distribution of colours and tones, and the boundaries between them. On shiny objects, such as metal or glazed ceramic, the highlights are very sharp and hard-edged, showing strong tonal contrast, while on a matt surface, such as a terracotta pot, there are almost no highlights and the gradations between tones are very gradual. If a texture is rough the colour will appear broken, as light will catch the raised parts, throwing tiny speckles of shadow.

T exture is often an important feature of still-life painting, with the contrast between organic and man-made objects, or that between reflective and matt-surfaced objects, adding an extra dimension to a painting, and sometimes even forming the main theme of it.

exercise 3

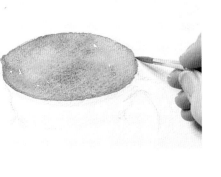

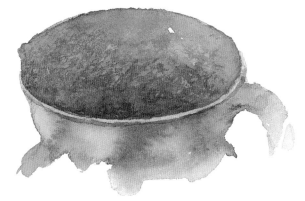

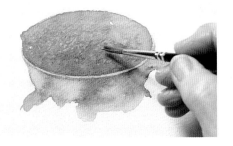

rough texture

For a granular texture such as the inside of this jug, drybrushing is a useful method. This is a variation of the method you practised for the lemon in exercise 2, but this time it is combined with touches of wet-into-wet work. Start with a brownish-green wash for the inside, and a similar mix but with more green for the glazed outside. Drop in touches of green at the top of the rim, then leave it to dry. Mix a stronger red-brown mixture, dip in the tip of the brush, and drag the colour over the paper so that it catches only the raised grain.

exercise 4

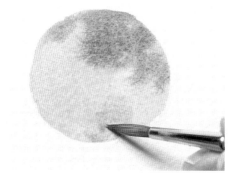

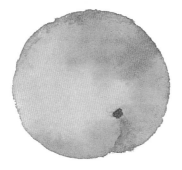

soft texture

An apricot has a soft, velvety texture that reflects very little light and hence shows only the most subtle of highlights. The best method for this is wet-into-wet, laying a base wash and dropping colour into it while damp. Place your board flat so that the colour does not flow down the paper, and be prepared to blot off any excess colour with a tissue.

exercise 5

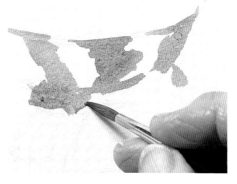

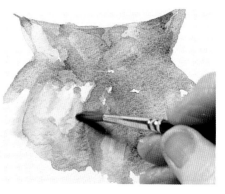

hard texture

This glazed jug has a shiny surface, but the glaze is quite rough, which breaks up the highlights. Start with a wash of a sap green and burnt umber mix, working on dry paper to leave hard-edged highlights. Wash water over the areas of highlight so that the next colours blend into it, and then build up the darks wet-into-wet, using a stronger mix of the same colours, and dabbing the paint on to create a speckled effect.

highlights
and reflections

working methods

Sharp, clear highlights such as those on polished metal or glass should be reserved as white paper by painting around them, which is why it is vital to place them before you begin to paint. But for soft, diffused highlights it is better to lift out colour, either while the paint is still wet or after it has dried.

Reflections can be painted as you work, using either the same colour as the object that is reflected, or a modified version of it. Do not make the reflections an exact copy of the object; they will usually be slightly blurred, and will take on some of the colour of the reflective surface itself.

Highlights bring a painting to life, as well as explaining the shapes and forms of the objects, and reflections can add exciting touches of colour. When you paint a still life that features shiny or reflective objects incorporate highlights and reflections into your drawing.

exercise 6

sharp highlights

Glass is not difficult to paint as long as you make a good drawing, placing highlights and dark areas accurately, as it is these that describe the form. This glass also has a reflection at the bottom, which is distorted by the curve of the body. When you have made the drawing, take grey paint carefully around the edges of the reflections and highlights.

exercise 7

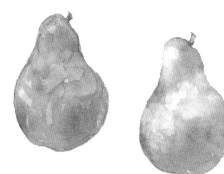

lifting out soft highlights

The obvious – and easiest – method for this type of diffused highlight is to lift out the paint by blotting it with a tissue before it dries. But if you want to give your work a more exciting, edgy quality, try out the method shown in exercise 8 as well.

exercise 8

reserving soft highlights

Start by laying a series of bold brushstrokes with sap green, leaving a large white area in the middle, and smaller ones at the top and side. Then drop yellows and browns into the green and leave to dry. Continue to work in the same way, with brushstrokes following different directions and covering the areas of highlight – these will remain lighter, as they have only received one layer of paint.

exercise 9

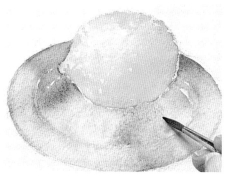

reflected colours

Reflections on a metal surface can be very crisp and clear, with hard edges, but it is often more effective to soften them, as you do not want the reflection to become more important than the object. Begin by painting the lemon, then work wet-into-wet for the saucer, using Payne's grey with a little alizarin crimson for the darker parts. With the paint still wet, drop in a deep yellow beneath the fruit and add a little also on the rim of the saucer.

using
gum arabic

G um arabic is the substance employed in the manufacture of watercolours to bind the pigment, but it can also be used as a painting medium, and is sold in bottles in most good art shops.

changing the nature of paint

Gum arabic thickens the paint and makes it more viscous, so that it holds the marks of the brush. With a little gum arabic added to your painting water, you can build up a painting in a series of separate brushstrokes without them running together. Do not use it neat; always mix it with water, in a proportion of no more than one part gum to four of water, or the paint may crack over time.

The gum can also be used in lifting out methods as it is soluble in water. Colour mixed with gum lifts out easily and cleanly even after drying.

exercise 10

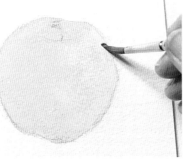

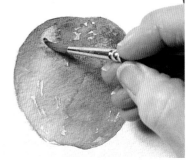

lifting out

If you intend to lift out only the top layer of paint, lay the first wash with the paint mixed with plain water, and leave it to dry. For this variegated apple the first colour is a mix of lemon and Indian yellow. Then mix cadmium red with gum and water and lay this over the yellow, making small, linear brushstrokes for the stripes. When dry, lift out further stripes. Create a soft highlight around the top by lifting out only partially, so that some of the red remains.

ELLIPSES

Painting still life often involves that most dreaded of problems – getting the ellipses right. Even professional artists sometimes have trouble with these, and there is no easy formula to aid you. However, it does help to understand the rules. An ellipse is a circle seen in perspective, and it changes according to your viewpoint. If you are standing looking down at a plate on a table, the ellipse will be quite open, but nearer to your eye level – that is, if you are sitting at the table – it becomes narrower. Thus, if you are drawing a tall vase the ellipse at the bottom will be more open than that at the top. It helps to draw two intersecting lines through the ellipse, one from top to bottom to make sure both sides are equal, and one across. Even if you are looking at a circle from an angle, the line from one side to the other is always horizontal.

Now the eye level is higher, and the ellipses become wider open. Those at the top are slightly narrower, being nearer your eye level.

The objects are just below eye level, so the ellipses are fairly narrow. If you were to hold a mug or glass directly at eye level, you would not see an ellipse at all, but a straight line.

With the objects placed on the floor, the ellipses become wide open. If you were directly above the front glass, you would see two perfect circles.

fruit with a blue and orange bowl

ellipses and arranging colours and shapes

F or this colourful still life, you will be using a combination of wet-into-wet and wet-on-dry techniques to build up depth of colour and surface interest.

setting up the group

Half the battle in still life is arranging the group the way you want it, because this is the stage at which the composition is planned and the colour scheme decided. Shirley Felts has placed the foreground fruit with care so that they provide a balance for the strong central shape of the bowl, and has used the diagonal line of the table top to contrast with the series of circles. She has deliberately restricted the colours to a range of warm reds, oranges and ochres, with the deep blue of the inside of the bowl providing essential contrast. Blue and orange are complementary colours, which enhance one another.

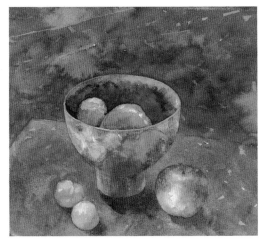

the finished painting

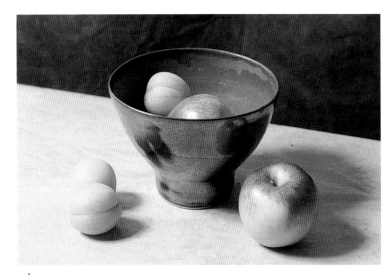

the set-up

YOU WILL NEED

Colours
Indian yellow
lemon yellow
alizarin crimson
cadmium red
ultramarine
sap green
burnt umber

Brushes
Large and medium
round

Paper and other equipment
300gsm (140lb) NOT
surface paper, stretched,
or 425gsm (200lb) NOT
surface paper,
unstretched
gum arabic
cotton-wool buds
3B or 4B pencil

Unusually, each area of the picture is painted separately, with the background put in last, so it is especially important to make a good drawing. Take particular care with the ellipses at the top and bottom of the bowl; you are looking down on the subject, so the top ellipse is relatively wide.

step 1

Start by painting the apples wet-into-wet, laying small washes of a sap green and lemon yellow mix and working alizarin crimson into it.

step 2

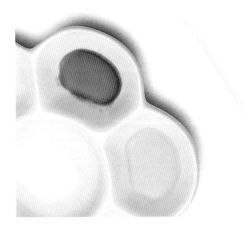

2 Build up the depth of colour in stages, using stronger colour. Then lift out highlights with a cotton-wool bud.

step 3

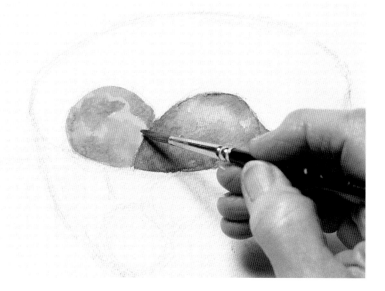

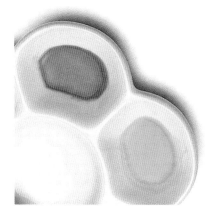

3 Let the apple in the bowl dry, and then work on the apricot beside it, starting with Indian yellow and then dropping in an orange made from the same yellow mixed with cadmium red.

step 4

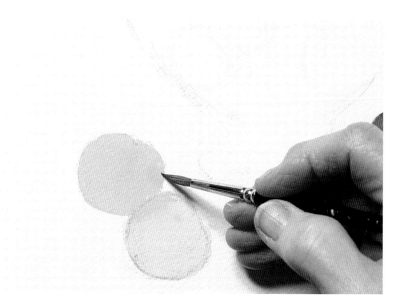

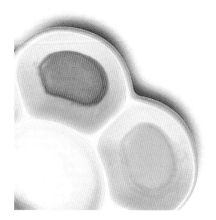

4 Paint the foreground apricots in the same way, but using less of the orange mixture. Blot lightly to produce a little tonal variation.

step 5

5 Take care with the painting of the bronze bowl, as it is important to hint at the reflections without giving them too much prominence. Begin with the orange mixture, mixing it with a little gum arabic to increase the glow, and then drop in first alizarin crimson and then a deeper orange mix made from burnt umber, Indian yellow and cadmium red. Work the stem of the bowl wet-on-dry, reserving highlights of yellow.

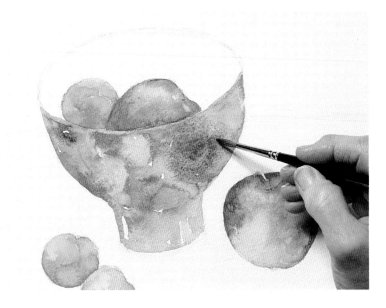

step 6

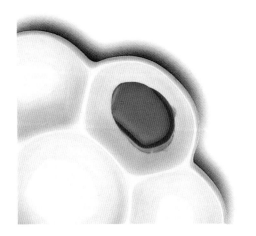

6 With the main colours in place, you can judge more easily the strength of colour needed for the blue inside. Use strong ultramarine for this. Turn the board upside-down to avoid smudging the earlier work, and take the colour carefully around the fruit.

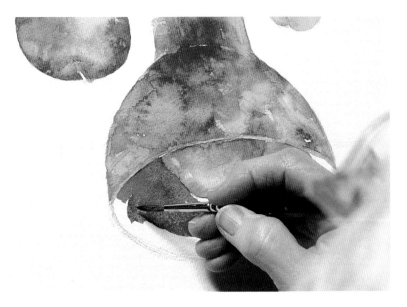

step 7

7 While the blue is still wet, and with the board remaining upside-down, paint the rim with Indian yellow, letting it flow into the blue.

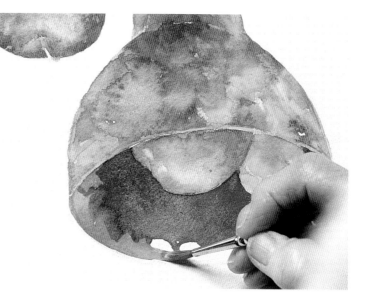

step 8

8 When all the previous colours are dry, paint the table with a mid-toned mixture of burnt umber. Do not make the wash too flat; apply it unevenly to create variations, and leave small specks of white paper.

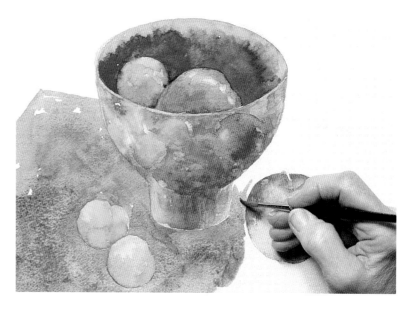

step 9

9 With another layer of burnt umber,
strengthen the colour and work in cast
shadows wet-into-wet. Burnt umber is
one of the earth colours, which break
up into granules, a quality that is often
exploited to create texture and surface
interest. Paint the stem of the apple with
the same colour.

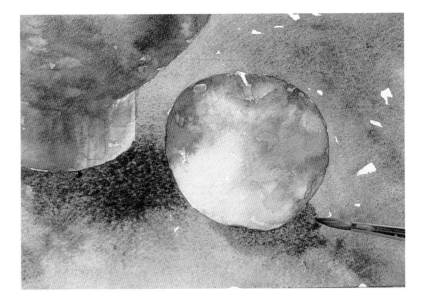

step 10

10 The colour of the red background must
be 'broken', as is that of the table, so do
not lay an all-over flat wash. Begin with
loose brushstrokes of an alizarin
crimson/cadmium red mix, leaving small
patches of white, and turning the board
to obtain a neat edge around the bowl.
Let this dry and work two layers of a
darker colour (add burnt umber) on
top, letting them run together to form
backruns and areas of granulation.

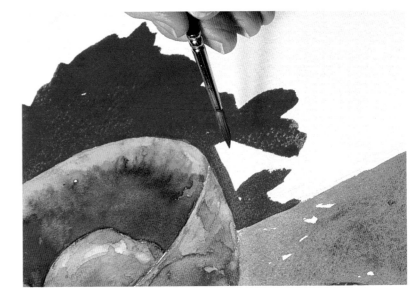

The wonderful glow of colour is the first thing you notice about the painting. This stems from the use of a limited palette of vivid, but harmonising, colours enhanced by the strongly contrasting blue. But equally important is the way the paint has been used. The objects take up a fairly small amount of the picture space, which could have left large, dull areas of background and foreground where nothing is 'happening'. But by means of bold brushwork, wet-into-wet effects and cleverly planned layers of colour, the artist has ensured that there is equal interest everywhere, with the background and foreground playing an important role in the composition.

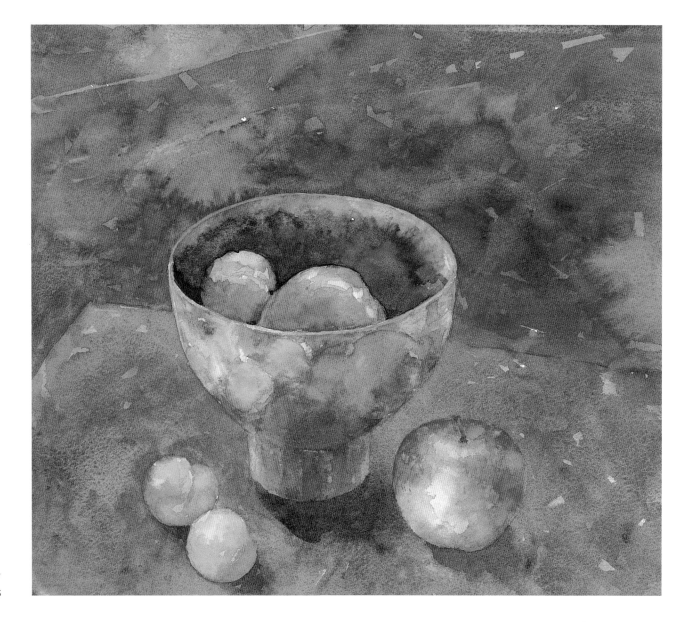

Fruit with a Blue and Orange Bowl,
Shirley Felts

CREDITS

The Publishers would like to thank all the artists who contributed to this book, in particular Jill Bays, Ann Blockley, Shirley Felts, Alan Oliver, Annie Penney and Trevor Waugh who demonstrated the exercises and step-by-step paintings.

Step-by-step photography was by Paul Forrester and Stuart Batley, and the still-life shots in the Painting Materials section were also taken by Stuart Batley. Marks to both for their hard work!

Additional photography credits are to: Hazel Harrison (page 29 bottom centre-right, page 47 bottom left and right; page 66); Alan Oliver (page 30); Annie Penney (page 82); Anna Watson (page 29 top, bottom left and bottom centre-left, page 47 top left and right); and David Watson (page 29 bottom right and page 48).

INDEX

Numbers in italic refer to illustrations and captions

(SBS) after a picture title indicates step-by-step demonstration

artists' colours 11

backruns 24, 60, *61*
Batt, Miles G.
 Near the Monhegan Light, Maine 75
Bays, Jill
 Swans at Laleham 21
 Willow Trees in Summer (SBS) 66-73
Becker, David
 Fall Colours 57
 Looking South on Michigan 74
blending *110-111, 113*
Blockley, Ann
 Winter Bouquet (SBS) *100-107*
broken colour 44, *124*
Brommer, Gerald F.
 The Pontevecchio, Florence 74
brushes 12-13, *12, 13*
 care of *13*
brushwork 10, *10-11*
 landscape *34, 35, 38, 42, 43, 45, 46, 48*
 still life *125*
 trees *52, 55, 57, 58-59, 62, 62, 66, 73*
buildings 74, *74-75*
 demonstration *82-89*
 techniques 76, *76-81*

Chan, Mary C.
 Kweilin Image 21
 Old Pine 56
clouds, see skies, clouds
colour, colours, 7
 complementary 41, 76, 82, 118
 for flowers 98, *98-99*, 100
 harmonious 41, 55, 125
 primary *11*
 'starter' palette *11*
 'warm' and 'cool' *11*, 65
colour mixing 39
 flowers *98-99*
 greens 65, *65*
 neutrals *76*
composition
 buildings 75
 flowers 90, *90, 91*
 landscape *20, 21*, 30, *39, 40*
 still life 108, *109*, 118
 trees *56, 57*
Corot, Camille 56

drawing boards 15
drybrushing *44, 52, 77, 77, 87, 106, 112*

Earnshaw, Adele
 Breakfast for Two 109
easels *see* table easels
ellipses 117, *117*, 119

Engle, Nita
 Lake Geese in the Sun 41

Felts, Shirley
 Fruit with a Blue and Orange Bowl (SBS)
 118-125
flowers
 colours 98, *98-99*, 100
 forms 96, 97
 shapes *99*
 techniques for *92-99*
form 96, 97, 110, *110*
Francesconi, Tom
 Spring Bouquet 91
Frey, Karen
 Wyoming Birch 56

grass, techniques for 72
gum arabic 116, *116, 122*

highlights 114, *114, 115*
Hinckley, Sharon
 Cybidium 90
 Tulips in the Garden 91

lamps and bulbs 9
landscape 20, *20-21*
 demonstrations *30-39, 48-55, 66-73*
 see also grass; skies, clouds; trees; water
Lazarus, Shelley

index

Morning Shadows 75
lifting out 26, *26-28, 33, 85, 103, 114, 120*
light, for working 9
 see also lamps and bulbs

masking fluid 42
 buildings 80, *81, 88*
 flowers 92, *92-93, 101, 105*
 water 42, *43, 44, 45,* 48, *49, 53*
masking tape 80, *80-81, 82, 84, 85*
McFarlane, James
 Waiting Till It Lifts 41
McIlvain, F.
 Florida Gulf 21
Mizerek, Leonard
 Boathouse, Maine 75

Nagel, Rea
 Pears 108
negative space 96, *96*

Oliver, Alan
 Norfolk Farm 20
 Summer Landscape (SBS) *30-39*
 Thornham Break 20

paintboxes 10
palettes 16-17
paper 14-15
 stretching *15*
pencils 17
Penney, Annie
 Tunisian Scene (SBS) *82-89*
perspective 81, *81*

Plummer, Carlton
 South Bristol, Maine 41
Rankin, David
 Kashmir Summer 40
 Mute Swan 40
reflections, 47, *47, 114, 114, 115, 122*
rigger brushes 10, *63*

scratching back 45
Scroggy, Hal
 Catalina Beach 57
shadows 37, 64, *64,* 66, *71, 72, 98-99, 124*
skies, clouds 20, *20-21*
 characteristics 29, *29*
 techniques for 26, *26-28, 33, 34, 50, 51, 54*
softening edges 43, 96, *96, 104, 110*
spattering 77, *77, 86*
sponges 17, *23*
still life
 demonstration *118-125*
 techniques *108-109*
students' colours 11

table easels 9, *9*
texture
 techniques for 77, *77-79, 82, 84, 112, 112-113*
trees *56-57*
 demonstration *66-73*
 shapes 61, *61*
 techniques for *58-63*

Wallace, Lennox H.
 Birch Colours 57

washes 22
 flat *22-23, 32, 68, 84*
 graded *23, 43*
 variegated *24-25, 32, 42, 46, 50, 102*
water *40-41*
 demonstration *48-55*
 techniques for 42, *42-46,* 48, *52, 53, 54*
 see also reflections
watercolour, characteristics of 6-7
 types 8-9
 see also colour, colours
waterpots 17
Watkins, Jeffrey
 Pear and Grapes 108
Waugh, Trevor
 Sunset over Jackson Lake (SBS) *48-55*
wax resist 78, *78-79, 84*
wet-into-wet
 buildings 75
 flowers 94, *94-95,* 100, *103*
 landscape 20, 24, *32*
 still life *108, 112, 113, 115, 120, 124*
 trees *56, 58, 60, 60-61, 62, 63, 66*
wet-on-dry
 flowers 100
 landscape *36*
 still life *122*
 trees 56, *62, 62, 63, 66*
 water 46, *46,* 48, *51*
Wiegardt, Eric
 Sunflowers 91
working position 9
Wynn, Ruth
 Gathering for Gardeners 109